DORIS MCCARTHY

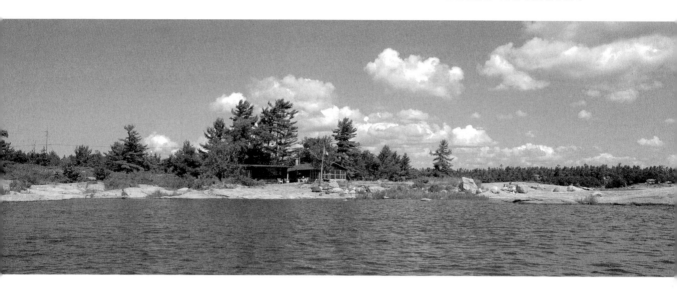

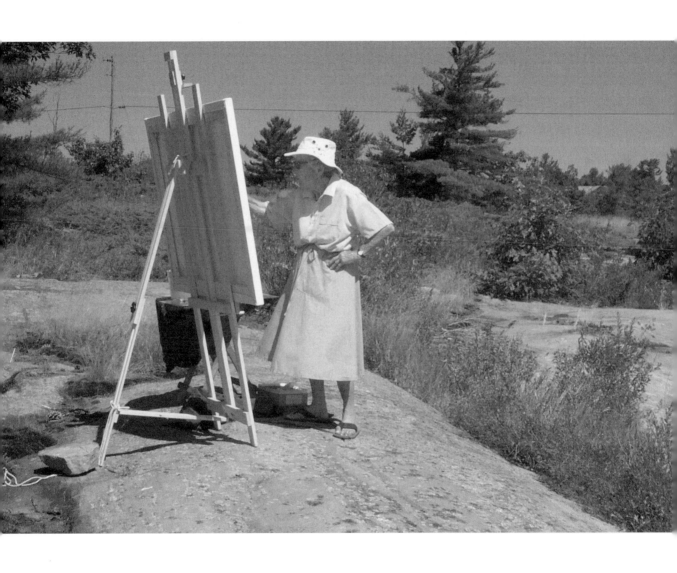

DORIS McCARTHY

Ninety

Years

Wise

by

DORIS
McCARTHY

Second
Story
Press

Library and Archives Canada Cataloguing in Publication

McCarthy, Doris, 1910–
Doris McCarthy : ninety years wise.

ISBN 1-896764-86-X

1. McCarthy, Doris, 1910– 2. Painters – Canada – Biography. I. Title.

ND249.M23A2 2004 759.11 C2004-905267-5

Edited by Charis Wahl
Designed by Counterpunch / Linda Gustafson
Printed and bound in Canada

Color photography of the paintings: Thomas Moore Photography
Thanks to all the people who made their paintings available for photographing

Black and white photo credits: Lynne Atkinson: 1, 2, 8 (top right), 10, 17, 27 (top, bottom), 30, 35, 36, 40, 45,
55 (all photos), 59 (top, bottom), 74 (all photos), 77, 81, 83 (bottom), 84 (middle), 87 (top, middle),
93 (top, middle), 94; Linda Gustafson: 8 (bottom), 59 (middle), 64, 84 (top, bottom); Ted Hunter: 42 (middle);
Fred Lum/*Globe and Mail*: 105; Beth McCarthy: 27 (middle); courtesy of Dale McCarthy: 25 (all photos);
Mar Schatzky (nee Wood): 15, 23; Tom Schatzky: 8 (top left, middle), 42 (top, bottom),
83 (top, middle), 87 (bottom), 93 (bottom), 102 (top, bottom)

This book is type set in Dolly, by Underware, The Netherlands;
book text titles in Toronto Subway, by Quadrat Communications, Toronto, Ontario;
book title in London Underground, by P22 Type Foundry, Buffalo, New York

*Second Story Press gratefully acknowledges the support of the Ontario Arts Council and the Canada Council
for the Arts for our publishing program. We acknowledge the financial support of the Government of Canada
through the Book Publishing Industry Development Program, and the Government of Ontario
through the Ontario Media Development Corporation's Ontario Book Initiative.*

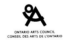 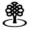

Canada Council
for the Arts

Conseil des Arts
du Canada

ONTARIO ARTS COUNCIL
CONSEIL DES ARTS DE L'ONTARIO

Published by
Second Story Press
720 Bathurst Street, Suite 301
Toronto, ON
M5S 2R4
www.secondstorypress.on.ca

Various McCarthy works, with an audio explanation by the artist, can be found at:
www.dorismccarthy.com

TO ALL THE PEOPLE WHO SHARE WITH ME

MY LOVE OF GEORGIAN BAY

AND THE SIMPLICITY THAT GOES WITH COTTAGE LIFE

ACKNOWLEDGEMENTS

I WANT TO THANK the many people who helped turn this book into a reality. Lynne Atkinson shared the life that is the substance of the book and gave me invaluable criticism along the way in finding and helping me choose the illustrations. Charis Wahl was the professional hand that guided the necessary revisions. Linda Gustafson designed the physical appearance of the book. Linda Mackey, my studio assistant, helped to identify all the paintings. To Margie Wolfe and the women of Second Story Press who worked to produce the physical book, thank you.

CONTENTS

Introduction / 9

THE SUMMER OF MY 92ND YEAR / 11

Portrait of a Happy Artist, *by Sarah Milroy* / 105

A Short Biography / 111

Chronology / 115

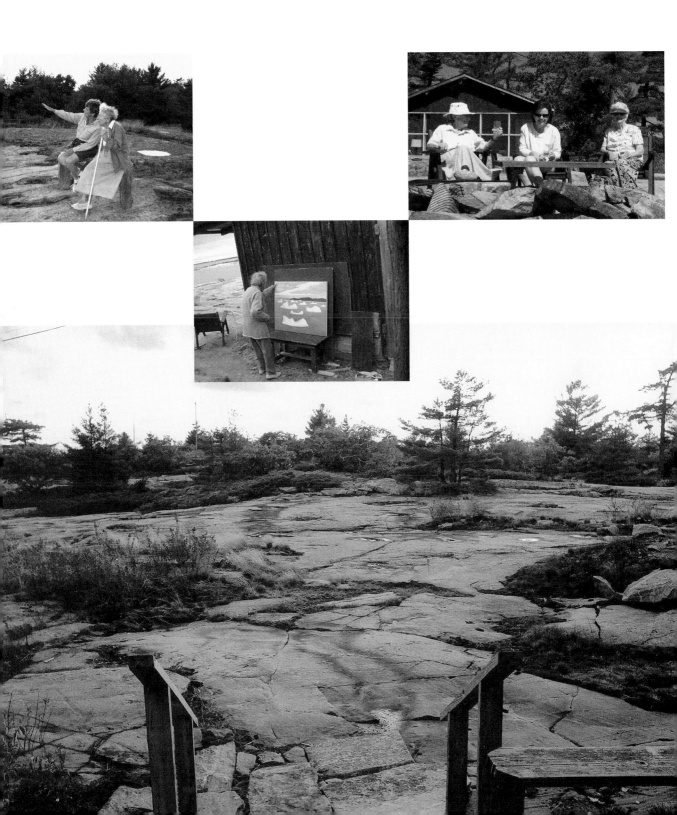

INTRODUCTION

TEN YEARS AGO I wrote my autobiography, in two parts: *A Fool in Paradise* covered the first forty years of my life, and *The Good Wine* carried my story through the next forty years. These books were about what happened to me and about my response, what I chose to make happen, and how both shaped me. Since then people keep asking for my "secret." How am I so old and yet so well? So happy? So productive? There is no secret. I am glad to tell everyone about the choices I make in my life and their results, the elements and attitudes that have added up to my zest for life and my joy in it. Come spend a few weeks with me during the summer when I turned ninety-two and you will know the answer.

CHAPTER ONE

June 2002. Driving up to the cottage is an escape to freedom. For two precious months I will have the simple life that I have learned to know as the best life.

The time there will be too short. Even at Fool's Paradise the days are too short for all the important things that fill them. Fool's Paradise is my home in Toronto, on the Scarborough Bluffs overlooking Lake Ontario. It is a paradise indeed, but life there is so densely packed with people and occasions and commitments in the community that it is anything but simple. My daybook, in which I enter what I have planned or what has been thrust on me, is so full that I can no longer remember what is coming tomorrow. I check every morning or, better, every evening to see what to expect and when.

It is a long time since that daybook has said "sketching with Barbara" or some other such visually creative activity. It is more apt to schedule a massage, or note who will be coming to consult me about career or

love life or whatever, or to remind me that it's time for my dear cleaning woman to come and polish me up. Important things, but probably not creative ones.

So what could be more important than the freedom to paint that I am driving to? For me the answer is people. I cannot say no to the old students who want to see me or to those who know me only through my books and want to meet me. Most of the year my door is open to all. But afterward, I need to withdraw, to get reacquainted with who I am, and that necessitates a retreat into solitude.

Now, for these few weeks, I shall be able to focus on sorting out my life and making the paintings that are the best way I have to share my delight in the world with my friends and everyone else.

—

JUNE 24, 2002. The road stretches ahead of me. I am already north of the sprawling commercial section of Highway 400, full of aggressive neon signs and the too familiar McDonald's, Wendy's, Tim Hortons, and clusters of gas stations. For a while I am passing only fields, green in the freshness of early summer; but beyond them are the low hills, layered in blues. Before long will appear the Precambrian Shield, with its dramatic cuts through colorful granite.

Every mile of this road has its own memories and associations for me. It must be eighty years at least since my Sunday school picnic was held at Bond Lake, with races that I never won and three-legged races that were so much fun that nobody cared about winning. There was ice cream and

cake after the sandwiches, and a great weariness on the bus coming back to the city.

The gas station just north of here was where we stopped for our first night of the adventurous trip west in 1982 in the motor home that I had rented from Anne and Ted. (You will meet them later.) They had seen us off in this wonderful and alarming vehicle and were left behind. "We" on this occasion were Nancy Wright, Barbara Greene, and I. Barbara, a teaching colleague at Central Technical School in Toronto, was, mercifully, a good mechanic and often needed as such in this temperamental home away from home.

Nancy was such an integral part of so many aspects of my life that it is hard to describe her. She was an artist whom I admired from our high school days together. When she joined St. Aidan's Church we became much closer. She would invite everyone at the early service to come home for breakfast, which she had laid out attractively with flowers, candles, colorful china, and a big bowl of fruit. I was toastmistress, presiding over an old flip-flop toaster and making sure that each guest's toast was the preferred crispness and depth of brown. Those Sunday morning gatherings were precious to us regulars; we considered ourselves a breakfast club, each with her own place but always with room for a newcomer, whoever he or she might be.

We were the church's official artists, creating the banners, plaques, mosaic frames for new treasures – whatever was needed. We planned and created the annual Nativity plays, made stage scenery for other people's dramatic projects, provided whatever visual material the rector of the day dreamed up as a desirable addition to the liturgy or

appearance of the church, and thought up some of our own.

Once Nan's mother and aged aunt had died, she and I took off on painting trips together, not only in Canada, including the High Arctic, but also to adventurous places overseas. Nan was game for anything, and I was glad of her enthusiastic sharing of whatever we encountered.

She was grace itself, every movement rhythmic, flowing. To watch her was a pleasure. And her gracious friendliness lived long after she had become forgetful and disoriented. A walk along Queen Street would be punctuated by little chats with whomever we met, whether known to her or not.

Barbara Greene was very different – brusque, matter of fact, very practical, and mechanically invaluable. Nan was taken aback by what she interpreted as rudeness until I convinced her that it was just Barbara's manner. From then on we were a comfortable family. That motor-home adventure was the first time the three of us had traveled together, and the edges had not yet been smoothed, but we were learning quickly.

By the time we had reached this first service center on Highway 400 it was getting dark, and we decided to park for the night. The next morning, driving out, I managed to catch the glass canopy over the gas pumps, and broke off a corner. For many years that broken corner was a reminder of our wonderful adventure.

<center>✄</center>

A FEW MILES FARTHER north is another important gas station. There, for years, I would meet Ginny in her car so we could drive in tandem to

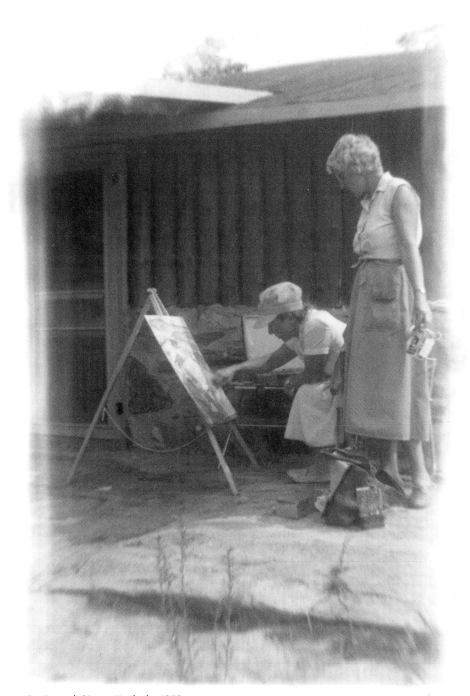

Doris and Ginny, Keyhole, 1959

the cottage. Ginny – Virginia Luz – was many things to me: a teaching colleague at Central Technical School, where I taught art from 1931 to 1972; a co-owner of our cottage and studio on Georgian Bay; and my companion for every day of what we still call "Our Wonderful Year," a sabbatical during which we traveled and painted together. She was my family at the cottage, sharing the studio and most other activities, notably Scrabble every evening. Alas, for the past several years Ginny has not come to the cottage. She finds the rocks too intimidating and is still cautious about the ankle she broke ten years ago.

South of Barrie we pass the small graveyard where four of us in our irresponsible youth dressed in sheets and came looming out from among the tombstones when we saw a car approaching. (The police stopped that game and sent us, chastened, on our way.)

The crest of the hill that drops down to Barrie brings to mind William Moore, the art critic who wrote the catalog for my Stratford exhibition in 1991. He is now director of the McLaren Art Gallery in Barrie and has recently accepted a group of McCarthy canvases for its permanent collection. It is a fine new gallery with a huge bronze breast outside, the work of my friend Marlene Hilton-Moore. (She gave a recent performance there in dance, drumming, and words.) It is increasingly a gallery where things happen as well as are exhibited. Marlene teaches in Barrie at Georgian College. She is a person of such vivid vitality that I can just imagine how alive her classes are.

North of Barrie, the next big landmark is Hillsdale, a small village just off the highway where Marlene owns an old Ontario house, with its patterned brickwork and its casual warm hospitality that embraces my

Marlene and Doris,
on the way down the trail
to the sculpture

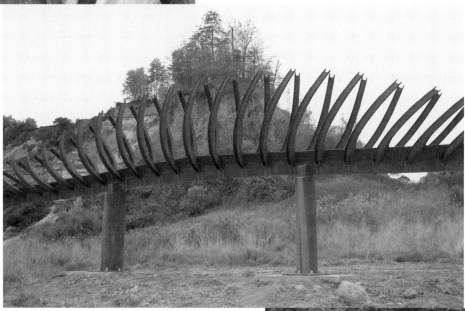

Marlene's sculpture,
located at the
end of the Doris
McCarthy trail, below
McCarthy's bluffs

cats and me and gives us a welcome rest from the road. The homemade soup, the catch-up with Marlene's partner, John McEwen, the inspection of the series of sculpted heads in her porch studio are the highlights of the trip north. In fine weather we have lunch in the back garden with the fountain, the bird feeders and their visitors, the glorious world of a Canadian summer. Marlene plans to leave a piece of appropriate and memorable sculpture in every province. One that delights me is the hollow bronze head that lives in a tidal inlet in Nova Scotia. High tide gradually fills it up and submerges it. Its gradual emergence as the tide drops is fun to watch.

When she came to Ontario, she decided that I was the hook on which she wanted to hang her work. She conceived Passage, the big iron form reminiscent of a fish skeleton that is now the climax of the walk down Doris McCarthy Trail through the ravine to the east of Fool's Paradise. Between its conception and its achievement lay the challenge of raising the hundred thousand dollars to pay for it. It was my dear friend and one-time housemate, Lynne Atkinson, who took on and met that challenge. (Much more about Lynne later.)

The completed sculpture dominates the little peninsula that juts into Lake Ontario at the end of the trail, a relic of the landslide that happened halfway through the stabilization of the ravine twenty years ago. Marlene has provided a sign that explains the complex symbolism of the sculpture, with dates significant in my life down one side and dates memorializing the geological history of the bluffs down the other.

I remember when Marlene and I first met. She telephoned me to ask me to sit for my portrait, suggesting that we could "talk about art." I was

horrified and said a prompt no, but weakened to the point of agreeing to let her paint me if I could be at my computer, working on the book I was writing. I was charmed at our first meeting and bless the day that she came into my life.

But onward and upward. Hillsdale is merely halfway to my Georgian Bay retreat.

Wabashene, where the highway leaves southern Ontario and starts me watching for the first outcropping of granite, ends phase one of the drive north. It has been a reliving of many rich times in my life, and a reminder of many wonderful people.

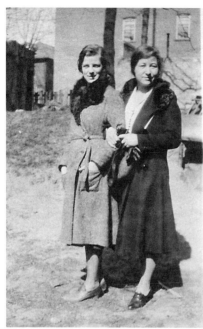

Marjorie Beer and Doris, about 1950

Marjorie and Roy Wood at Killarney Mountain Camp, 1937

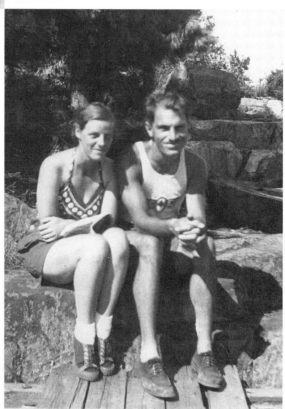

CHAPTER TWO

As LONG AS I have been driving this road I have watched eagerly for the little island with the cottage near Port Severn. It says to me, "Cottage Country!," words that conjure up such a treasury of memories and associations that I can hardly sort them out. There were the early days in Muskoka: Silver Island, Marjorie Beer and I embracing it as if we had reached heaven; our days in and out of the water, our prowess in the canoe; the adventure of keeping house with Mother; Marjorie appointing herself "Queen of the Pantry"; Sunday evening song services, and the blended voices carrying over the water.

Marjorie Beer was the second daughter of the Beer family, which moved into the big frame house on Balsam Avenue next door to the McCarthy family home in the Beach district of Toronto. We two, aged eight and nine, recognized each other as kindred spirits and stayed bosom friends throughout Marjorie's too-brief life. Until I had shared it with her, no experience of mine was complete. Our intimacy continued

through her marriage to Roy Wood, the birth and raising of their four children, our widely separated careers – Marjorie's as a wife and mother, mine as an unmarried artist and teacher. Her children, now married with families of their own, are my children, too. But it was those early summers at the cottage on Silver Island that enabled our friendship to deepen and for us to discover increasing joy in it.

No wonder that, many years later, after very good but quite different experiences of painting trips to the Gaspé region of Quebec and overseas, traveling in Europe and even around the world, I began to hunger once more for a cottage and the life it implied.

✖

THAT HUNGER TOOK ME to Georgian Bay in August 1959 for the brief rental of the Knothole cottage that ended in the purchase of it and its neighbor, the Keyhole, that autumn.

Owning the cottages is a partnership, an arrangement that had my lawyer shaking his head and warning me of the hazards. Ginny Luz and I had heard about the simple but charming cottage from Marg and Gwen, two other partner friends who had rented it twice before. Since Ginny had become part of the art staff at Central Tech, we had been spending joint holidays, usually with a few others, painting on the Gaspé coast or in the Haliburton Highlands. After many years of boarding house life I yearned for the sort of cottage I remembered as a child. This place that Marg and Gwen knew sounded good, and after seeing slides of it and its surroundings, we rented it for the two weeks following their stay.

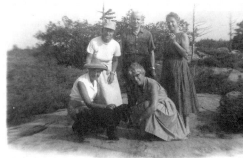

Doris and Ginny (top left and bottom right) with friends, 1959

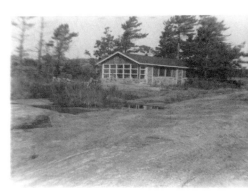

Knothole, summer 1959, before the studio was added in 1961

Doris painting on the rocks, 1959

Getting there entailed a nerve-racking drive through the backwoods, with a corduroy hill at the end – adequate in dry weather, impossible after rain. But once we were there it was love at first sight.

When we heard that it was going up for sale, we panicked. Neither Ginny nor I could afford to buy it. Nor could Marg and Gwen together. With Yvonne Williams, the stained-glass artist and friend who had originally discovered and recommended the cottage, we all decided that as a group, we could just manage both it and the cottage on the adjoining lot, to protect our privacy. We figured that renting the second cottage to friends would help pay the taxes on both properties.

And so was formed a partnership.

We made careful plans to avoid friction, dividing the summer into four three-week periods, one for each partner, and agreeing that each in turn should choose which dates she wanted. Because Ginny and I were each a full partner and wanted our time there together, we were entitled to six weeks, not necessarily consecutively. (During your stint, you had the use of both cottages, and you were responsible for lending or renting the second for that period.) We agreed that if and when a partner wanted out, we could buy her out for what she had originally paid but no more. We then had the option of inviting a new partner in or carrying on with those who remained. (The personnel in the partnership has seen many changes, but there has never been a failure of cooperation and accommodation to new concerns.)

Before we had quite finished negotiating the details of the partner-ship, we were tearing down a partition that cut up the space too much, when the owner happened to walk in. Although we had told him we

Doug and Audrey McCarthy,
and Doris, with Megan and Beth,
August 1969

Doris, July 1967, searching
for a painting location

Dale McCarthy with
Beth and Megan,
July 1967

wanted to buy, no money had changed hands. We held our breath, waiting for his reaction, but he said nothing. We realized that for him, as for us, one's word was one's bond.

—

JUNE 2002. The car is loaded, as is Rick's car, which is following mine. He is the young man (forty is young to me) who occupies the guest suite at Fool's Paradise and gives me the support that, in my nineties, I need – and am learning to accept. Rick maintains a sensible distance behind me, letting me set the pace but staying near enough that he can see that I enjoy clear sailing and have no difficulties with the car or with traffic.

I met Rick in 1991 when he and my grandniece Beth McCarthy were a couple in Guelph, in southwestern Ontario, where they had been students. Rick Dzupina is a creative weaver, and I bought a small piece of his work from his exhibition in Guelph. Later Rick and Beth moved to a flat in Toronto; it was from there that they came to see me one afternoon to ask if and when they could be married at Fool's Paradise. We talked logistics and went over to the local community center to check out size and availability of the big hall for a reception.

But, surprise! On reaching home that afternoon they no longer wanted to get married; Beth found an apartment and moved out of their flat. Rick was to ride out their lease and would be at loose ends after that. I realized that I needed a cat-sitter for April, when I was to be off painting in Ireland, and asked Rick if he wanted to move in for the

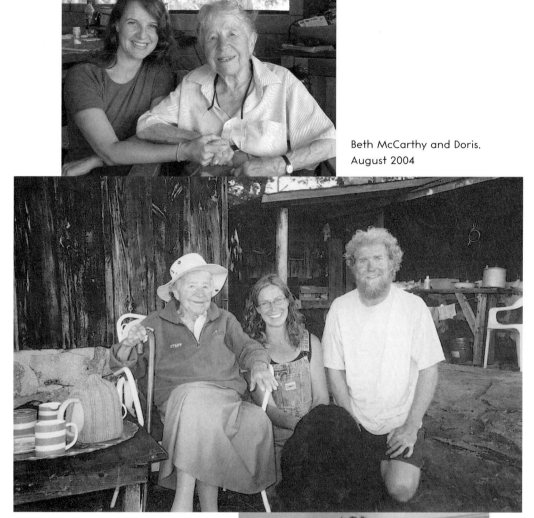

Beth McCarthy and Doris,
August 2004

Doris with Pam and Kit
at teatime, August 2004

Rick

month. He agreed happily. Who wouldn't welcome Fool's Paradise as a place to spend a spring month with two cats?

I liked Rick so much and felt so comfortable with his appreciation of my home that I invited him to stay on through June, longer if it suited him. I would be taking the cats with me to the cottage, but home is always the better for having someone looking after things. (I felt some ironic amusement at Beth's rueful reaction – "She's my aunt!" – but I paid no attention.)

My one-time study has its own sleeping loft and bathroom, so we each had enough privacy to find living together easy. Rick was wonderful, taking on all the maintenance jobs inside and out – cleaning the eaves, repainting where needed, repairing torn screens, and even cooking dinner occasionally.

Rick was here when I had my horrendous car accident in 2001. I drove into the ditch, hit a culvert, and knocked myself out on the windshield. The car turned two complete somersaults before coming to rest thirty feet forward in a ditch. It was totaled; I had a broken wrist and was considerably and painfully battered. He arrived on the scene within minutes, saw me into the ambulance and to the hospital, alerted Lynne Atkinson, and for the next two weeks laid his mattress on the floor beside my bed in the studio and was there to help me through the night. I shall never forget his kindness then. And here he is, following me north in his car, ready to go on helping me.

Lynne Atkinson had lived with me for ten happy years until she found and bought her own version of Paradise. But she has never given up her concern for my welfare, and after the accident, it was Lynne who took

responsibility for the day shift and made sure that I was never alone during the slow, painful weeks of my recovery. Rugged independence and helping others used to be my style. A teacher spends her life watching for a need and meeting it, if she can. I know the pleasure of being able to smooth the road for a younger person in difficulty or for an older one less capable than I. I know that Rick and the others who offer helping hands to me today experience the same satisfaction. It helps me to accept.

<div align="center">✖</div>

HERE IS PORT SEVERN, offering me the first glimpse of the blue waters of Georgian Bay and the tiny cottage on the small island that tells me I am now in holiday country. Another hour or so and we will be there, twisting through the woods on the road that has sixteen zigzags. (I've counted them!) The last zigzag will bring us to a sharp hill that drops to the beginning of a road among the trees that is hardly more than a trail.

When we get there the grass is high between the car tracks. Early summer and not yet enough traffic to wear it down. But we drive over it to the little bay that separates our peninsula from any neighbors.

This little bay is known as the Keyhole because of its shape – round and reached by a narrow neck. Our three cottages (to our surprise and delight, when we purchased the peninsula in 1971 we discovered a third cottage, which we named Cubby Hole, on the far side of the ridge) have water on three sides and no close neighbors, which gives us wonderful privacy. The Knothole cottage, my goal, is the middle one. I can see it through the pine trees as soon as I reach the high breast of rock behind it.

The cottage is a simple one-room rectangle with windows on three sides looking toward the bay. It is fieldstone to waist height and then half logs to the roof, which is open to the rafters. (In such a modest building it would be pompous to call it a cathedral ceiling.) At the back, away from the water, there is a partitioned-off dressing room with an open kitchen beside it. The studio, six feet away and added later, has the same stone walls, with board and batten up to an almost flat roof. Rick watches me safely over the rocks and then unloads both cars.

The cats come first. Rick had brought Gwen and Worcester, each in a crate. I have brought little Tigger, loose in my car. All three are in bliss to be out, to run around exploring. After the cats, Rick unloads the boxes of groceries and the cooler of frozen stuff. Finally he carries all the art supplies into the studio.

The cottage and studio speak eloquently of the same unselfish, caring friendship that I appreciate in Rick. Pamela and Kit, my young partners in the properties, have cleared out the canoes, kayaks, wheelbarrows, and ladders that live in the buildings during the winter, and both cottage and studio have been swept clean. They put the furniture where I like it, and have even washed and polished the many windows that make living here such a joy to me. They were up the weekend before my arrival to make sure that I am welcomed by my second home, and then left, so as not to intrude. My summer has begun.

✖

PAMELA AND KIT are the young couple who bought into the partnership when Yvonne and Ginny and I realized we needed youth and brawn. Pamela is the second daughter of Joan and David Smedley, who own the Cubby Hole, the small cottage on the other side of Holy Point. She has been around here since her teens, when she was an attraction to all the young men in the district. She met Kit when they were both taking a wilderness survival course. After they married, they spent many summers or parts of summers in the Cubby Hole and, later, as tenants in the Keyhole cottage. Their first child, Andrew, was about six when the second, Robin, arrived, bringing drama into their lives. Robin was born with bone-marrow leukemia, and Pamela and Robin spent much of his first year together in hospital while the doctors fought, successfully at last, for his life and health. Readying the cottage and studio for me is typical of their thoughtfulness and cooperation.

—

ONCE RICK HAS unpacked me and shared a meal, he has a swim in the still-chilly water of Georgian Bay and heads back home. I am alone with the rocks, the waves, and the familiar islands, too far across the bay to limit the sweep of the whole sky. I am alone with myself. "Hello, Doris," I say, and, "Thank you, God, for this dear place, for my safe trip, for every day that lies ahead."

My friends from the Keyhole cottage saw our cars crawling over the rock and come over to greet me and offer any help needed, but settling in is a privilege I cherish and want to do at leisure so I may relish each step

and be sure that I know where I have put everything. The simplicity I value so much depends on having few things but keeping them in order.

As long as I have food and shelter, happiness doesn't depend on my standard of living. All of us who lived through the Great Depression, before the social safety net, learned that. (Ginny Luz remembers the Depression as a time of laughter around the dinner table, and the good-humored resignation with which the Luz family made room for two cousins and grandmother in their already full house.) Life wasn't easy, but it was good. Money was so scarce that it offered few options or temptations.

After my first year of teaching I spent an idyllic two months with Ethel Curry in her father's hunting shack in the north woods of Haliburton. (Ethel and I became friends at the Ontario College of Art in Toronto.) We could take only what we could carry on our backs – half a dozen books, painting equipment, basic foods, and very little clothing. We painted and drew, explored the nearby lakes, sometimes hunted partridge and fished, and read during meals. It was a full life and taught me that in simplicity there is contentment.

This is one reason why I resist any impulse to add amenities to the cottage. I realized early that the more labor-saving devices I acquired, the more I had to cope with breakdowns, the more complicated booklets of instructions I had to master, and my time for creative work did not greatly increase. However, I am grateful for electricity here and for the hand pump that meant we no longer needed to lug buckets of water up from the bay. My gratitude is to Ginny, who wanted the pump because she couldn't share in the carrying; and to Kit, who services the

pump as needed. Pump and electricity protect my painting time.

Tonight I find two full pails of water waiting for me, and dinner is quickly reheated on the stove. I need it after the day's work. The cats are fed and have gone out again. Will they come in for the night? Who knows? I don't really care – they are safe anywhere around here.

＝

It is still daylight, and I must go out to relish my front garden of smooth granite with its tufts of grass and its shoreline of boulders. Beyond them I greet the Giant, the long man-shaped reef that becomes the Indian Chief when water is low and the flat rock appearing at his head looks like a feather. Tonight the feather is high out of the water. Good. Low water means a generous addition to our shoreline, although it is hard on the boaters.

Where is there ever as much sky as here? Tonight there are only a few small clouds, and they are turning rosy. The cottage faces east and south, and the sun sets behind us, out of sight. The water is calm tonight and beginning to reflect the afterglow in the sky. Sunset means that the mosquitoes will soon be out. Bedtime. How I love this place! And how I am now looking forward to that bed under the windows!

I usually sleep well here, but tonight I lie for a while, letting the stiffness in my back reduce, reliving bits of the day, vividly aware of being here, and seeking words to express my gratitude.

CHAPTER THREE

June 27, 2002. The morning starts with first light, and I am glad that it wakes me before sunrise. I lie in bed stroking Tigger, who has spent the night with me, waiting for the magic arc of the sun to push above the far shore. Then I pull myself up and out of bed, ready to haul my nightie off and wrap myself in a towel, slip into my sandals, and make for the water. Each year I have to choose a spot where I can get in without sharp rocks but where there is a handhold so I can pull myself out again. I have not yet scrubbed the algae from the first two steps, so I promptly slide into deeper water – and today it is *cold*! I am out again as quickly as I can scramble, but before I can even retrieve my towel I begin to feel the warm glow that is my reward for taking that frigid plunge. Worcester has come down to the water to watch me, and he accompanies my retreat to the cottage but keeps getting ahead of me and falling on his back to beg me for a tummy rub.

As soon as I am dressed I hang my towel out in the sun, make my

bed, check that any leftover mess is cleared away, turn on the music, and haul out the weights. This is a discipline that must be in its thirtieth year now – my daily leg-lifts with eight pounds on each ankle. My immediate reward is breakfast, my favorite meal of the day, but the long-term reward is greater.

The bottom of the refrigerator is crowded with bags of Florida oranges, enough to last me until August. I allow myself one a day, after my morning pills. Most are vitamins, part of my habit of taking care of my health, but a few of the pills are in recognition of the extra hazards of being in my nineties. My homemade granola is full of nuts and other luxuries, and so wholesome that I feel justified in ending breakfast with a slice of my own white bread toasted and slathered with margarine and garnished with McCarthy super-marmalade. These days I don't seem to gain weight no matter what I eat.

Then the chores – the dishes done, the cat food replenished, the pee pail washed and put out to sun. I haven't been here long enough to have laundry, but I should do a stint of grass clipping before I allow myself to enter the studio. I am stern with myself and get out the shears to start the annual chore of cutting a path through the long grass to the privy. This is never as much fun as painting, but I tell myself that it is a way of loving the cottage and makes living here more comfortable and efficient. Once I get started on the job it captures my interest, and I find myself enjoying the now visible path. Even carrying the raked-up grass to the hollow that I use as a composter gives me pleasure.

✺

At Last! That's enough for today. Finally I may go into the studio. This morning I start on setting it up: organizing the easel, the tall side table, and the paints, which I lay out on the workbench in spectrum order so that when I reach for a color I know where to find it. July will be for painting the big canvases in oil; the watercolors, their special brushes and paper are left in their carton and portfolio until I am ready to turn to them in August. I prop a blank canvas up on the easel, set up a chair at the right distance, and sit down, not only to rest but also to think about what I want to paint first.

I have brought thirty watercolors and oils from my trip to Costa Rica, and now I spread them out on the floor, waiting for the familiar jab in the solar plexus that says, *This is it. This I want to wrestle with, to keep what I captured there but to tighten the composition and make it better.*

My choice is a small oil landscape that uses the sweep of the shoreline to take your eye back to those interesting hill shapes a few miles across the Pacific, with its incredibly long unbroken rollers that were so new to me. I have to decide which should be most important in the canvas – hills, ocean, or the pattern of clouds crossing the sky.

Then comes the next exciting step, unpacking the acrylics and laying them out on the side table beyond the piece of glass that I use as a palette. I fill the water pots and fill the brush holder with the three or four brushes that I reserve for acrylics.

I start a canvas by trying the composition in thin acrylic, as transparent as watercolor and as quick to dry. The first sweeping stroke places the horizon, the next the curve of the shore. I have to decide if they break up the rectangle dynamically. If they are right, they will already be offering me energy. I try a slightly lower horizon line and find

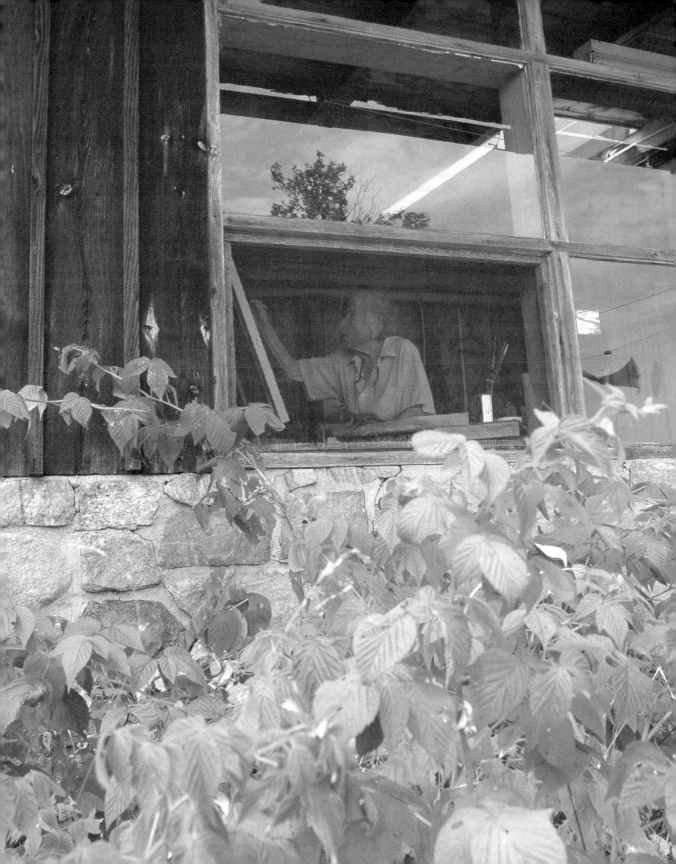

it better. As every relationship is critical, here is the great advantage of the tentative character of the acrylic beginning. It allows me to modify, erase, move any line or form until I am sure that the design is right, that every line is in harmony or tension with every other, that the shapes provide repetition with variation, which is as basic to good composition in visual art as it is in music. The morning is not long enough; my watch tells me that it is already noon.

I break for lunch, carried on a tray to the table in front of the studio, where Kit has put the two chairs that Ginny and I used for so many years. Is the gull that lands near me the same one that was here last year? I throw a scrap of bread, and the bird takes a step nearer. It must be the same, the one I named Roxanne. I guessed her to be female from the gentleness of her movements compared with those of other gulls that have claimed this territory.

Back in the studio I find my gobs of acrylic all dried up on the palette. But the glass cleans easily, and soon I am at work again, strengthening the colors here and there, gradually working down to the final tone.

Four o'clock arrives, and I hurry in to the cottage to put the kettle on and set the tray ready for anyone who turns up for tea. Today it is Anne and Ted from the Keyhole cottage – dear Anne, the eldest daughter of my lifelong friend Marjorie. Ted, her partner, has also become my friend. We have much to catch up on. I must hear about their days here ahead of me, and their days before coming north. Anne has news about Marjorie's other children and grandchildren, now adults. They are my family, and I am an eager listener.

They peek at my day's work and say that it is good. I love to hear this,

Doris and the studio,
summer 2002

Tigger, Anne, Doris and
Jitke, September 2003

The studio,
summer 2002

especially as my first concern is whether my painting speaks to someone else. I value input, even from non-artists, and no longer feel defensive about showing work in progress.

<div align="center">✖</div>

THE PLEASURES OF SOLITUDE. Like most hours, this one passes too quickly. Anne and Ted carry the tray in for me and start back to their own cottage. Once again I relish being alone, and start organizing my dinner, washing up the tea things, setting the table in the cottage with my reading rack in place and my current book open on it. While dinner is cooking I settle, with a sense of great luxury and virtue, in my favorite chair with its view – my rocks, my little cove, my sweep of sky and the beautiful little island directly opposite our peninsula where my friends will be coming next weekend – and ask myself what have I done to deserve all this, and thank God for it. I take my first sip of the rye on the rocks that is my daily indulgence, read a clue from the cryptic crossword puzzle – Anne's sister keeps me supplied with them – and try to figure out the answer. By the third clue the timer sounds the news that dinner is ready, and I am ready for it. No wonder I love these weeks with their orderly days in the midst of great natural beauty.

In the early evening I find my wooden staff among the paddles standing in the corner of the studio, and set out on the exciting rediscovery of the fullness of my world. Tonight I decide to follow the shore on the right, away from the Keyhole, and with staff to steady me where the rocks are too rough for my deteriorated balance, I go out to the

very end of Holy Point. I have the fun of seeing how close I can get to the gaggle of gulls before they sidle away. Soon they are smoothly airborne and fly off, circling back to where I have come from.

Holy Point is a long shelving rock, with a pattern of pink zigzagging along its gray length, the colors becoming much richer as they continue under the water. From here I can see around the point to the Cubby Hole, the third cottage of our community. The rocks are different on this side, much rougher, in long spines, and mostly black. I am cautious and test each step with my staff. Yellow sedum is already starting to bloom in the crevices at the front, but the cottage is closed up, waiting for Joan and David to arrive next week.

(David Smedley's older sister, Flo, is the dear friend whom Ginny and I used to have up to our cottage before we bought the point. Later, we sold the little cottage on it to Flo and her sister Mary.)

Before reaching the cottage, I turn inland, up the steep little path through the woods to the clear level rock above, where David will park his car. Now it is easy going over stretches of smooth granite that take me higher and higher, to the summit with the clump of pines that we planted to mark the place where we buried Marjorie's ashes. I watched the slow growth of those pines until I could see them above the breast of rock, and they never fail to say "Marjorie" to me. They now dominate the skyline. This summer I am going to install the stainless steel sign that I have made:

> Marjorie Beer Wood, 1909–1974 and
> Roy William Wood, 1906–1998
> They loved each other and this place.

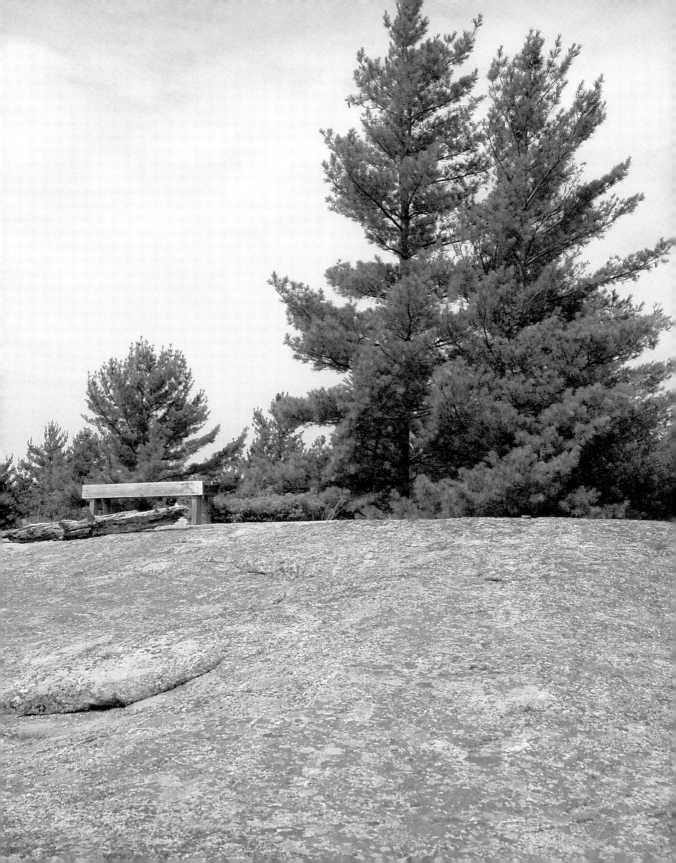

Beside the pines is the bench I built and named Flo's Flop. It was to be a midpoint resting place for Flo on her increasingly difficult walk from the Cubby Hole to join Ginny and me for Scrabble. Every feature of my ramble vividly brings back a friend who shared it.

―

FLORENCE SMEDLEY moved to Toronto and into my life early in the 1940s. She was a slender young woman with a lovely head of snow-white hair and beautiful skin. Before she was well enough settled for her mother and father to join her, she lived alone in the Beach district. As I was also on my own there, we did many things together. I can see her now, cycling along Queen Street East, her skirt and hair flying. Staying with Ginny and me at the cottage made her part of this place, so when we acquired the Cubby Hole it seemed natural to sell it to her and her sister Mary.

Unique among my friends, she had a wacky appetite for adventure that matched my own. One summer, in 1955, Flo and I, with Ginny and her brother, Edgar, went overseas, including an exciting week in Paris. One evening Flo and I went walking along the Left Bank of the Seine, past the book stalls, until our attention was claimed by an antique shop. In the window was a horse. Was it alive? Impossible, but incredibly lifelike – it had to be stuffed. Around the corner we found another window, candlelit. At the refectory table inside, reflecting the candlelight, sat a beautiful dark-haired woman; opposite her was a gentleman in evening dress. Each held a glass of ruby wine that matched her long gown. Were they also stuffed? No! While we stared, he raised

his glass in grave salute, and they locked eyes as each took a sip of wine.

We reported our adventure, our discovery, to Ginny and Ed. They only half believed us and refused to come to see it. But the next evening we all went walking. The same antique shop yielded the same strange sights – the stuffed horse, the lady and gentleman at either end of the dark candlelit table sipping red wine. Only in Paris.

In September, Flo was laughed at by her colleagues at Leaside High School in Toronto when she told them about the amazing antique shop. They didn't believe her and teased her about her vivid imagination.

Five years later, on my year around the world, I was staying in a hotel in Delphi, Greece, whose sacred shrine has supernatural powers. One night I shared a dinner table with a young woman who lived in Paris. I asked her if by any chance she knew of this intriguing antique shop on the Left Bank. She knew the place – the lady and gentleman were friends of hers! And she knew that they had bought the stuffed horse from a merry-go-round in Brittany. My triumphant letter to Flo ended up on the staff-room bulletin board at Leaside High. Vindication!

From Flo's Flop I look down on my own Knothole cottage beyond its group of large pines. Through the tops of the pines I see again the far shore, a narrow blue strip broken here and there by the nearer islands. I take time to greet each of them in more detail than I did last night, but the sun is setting behind me, so I take up my staff and pick my way down to the cottage. I shall spend this second evening as I hope to spend many, playing Scrabble against myself, right hand against left hand. Tonight I shall settle for only one game. I am tired, and the cot in the corner is luring me.

Thank you, God for the blessings of this day, for the dear friends who prepared my welcome, for the beginnings of a canvas – for far more than I can list before I am asleep.

—

NEXT MORNING the return to work is a tense moment. I look critically at the canvas I started; even a day gives me enough detachment to be useful. It will take me the rest of the morning to finalize the acrylic underpainting. Then will come the delicious moment of getting out the oils and beginning the final painting. By tomorrow night I should be able to give it the acid test: take it into the cottage, put it up on the rack, and live with it long enough to give any fault time to be noticed and dealt with. My second canvas will be on the easel by then, and the whole fascinating process will be under way again.

Friends of Anne and Ted have arrived and join the three of us for tea. (Any new person introduces a new dynamic in a relationship.) They tell me how they met Anne and Ted. We talk about the pleasure of introducing this beloved spot to newcomers and welcoming them as friends. I tell them about my sad experience of discovering that a valued friend could not forgive me for making friends with her new assistant. Her feelings for me were possessive, fatal to a good relationship.

Then, as a precaution, I explain my summer policy of working undisturbed until four o'clock and then being available to old friends and new.

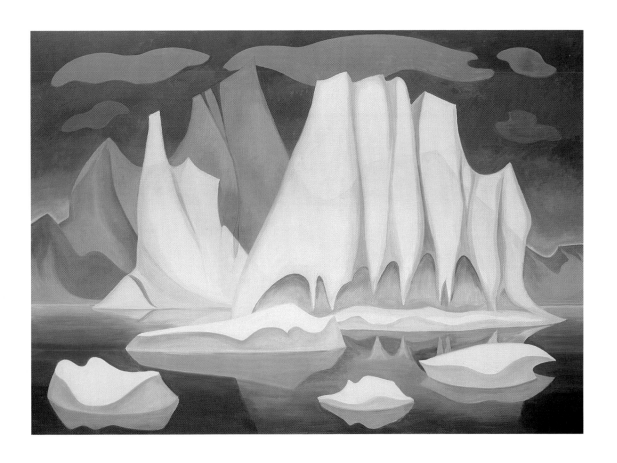

Iceberg with Icicles, completed February 1, 2000
oil on canvas, 152.4 x 213.4 cm

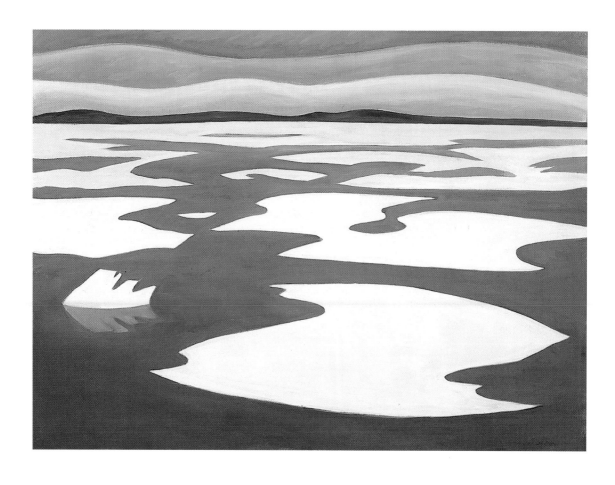

Leaving Resolute, completed August 30, 2002
oil on canvas, 91.4 x 121.9 cm

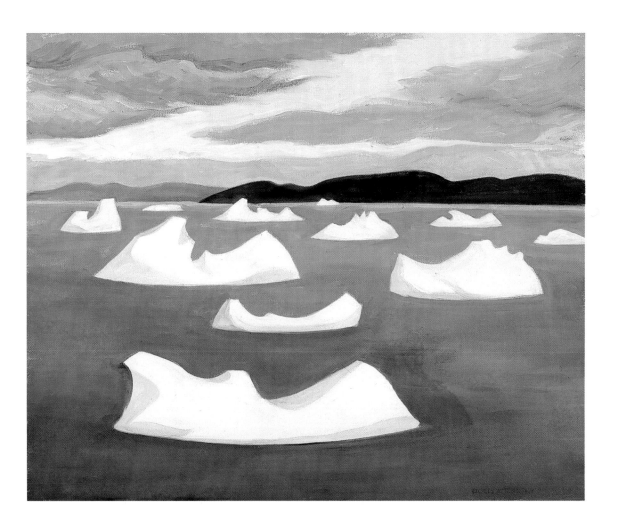

Ice in Lancaster Sound, completed September 1, 2002
oil on canvas, 76.2 x 91.4 cm

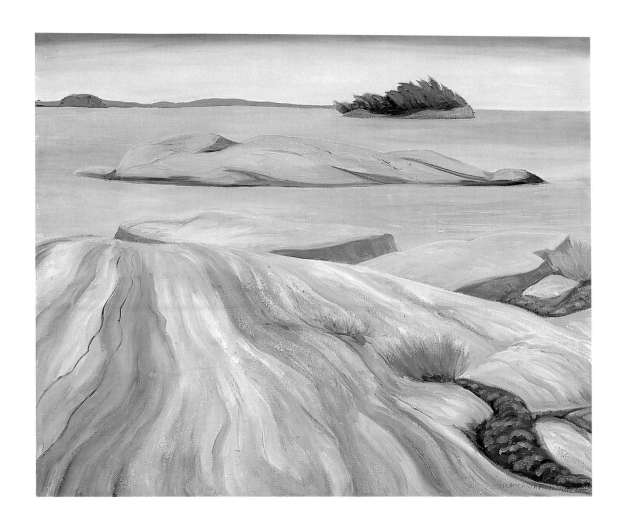

Jukes and the Giant, completed July 15, 2002
oil on canvas, 76.2 x 91.4 cm

CHAPTER FOUR

July 1: End of the Bonus Days. I have made a calendar to help me keep track of the weeks. With so little to distinguish one day from another, and having left my daybook with Rick so he can know my commitments, I need this help.

Before I take a finished canvas off the easel I mark the date on the back; that becomes the official designation of the work. Titles are apt to be similar, even repeated, but not dates. Alas, from now on those dates will be in July or August and, far too quickly, September.

A good thing about July is that it brings Pam and Kit to live in the Keyhole, once Anne and Ted have gone back to the city. We three have great discussions over tea. They pick my brain and I pick theirs. They are curious about how I keep so healthy at my age. I tell them about the camp I was sent to, early in the 1939–45 war, where we were taught about nutrition and the food rules I have followed ever since. Pam and Kit are leaning toward vegetarianism and not only tell me about the good recipes

they have learned but also invite me to share the results. I am impressed.

They already know the pleasures of exercise. I watch them skimming by in kayaks in the early morning. I report that my doctor calls it the most important single factor in good health, and we agree that regular exercise is easiest here, away from their teaching duties and my disorderly life at Fool's Paradise, although even there I do my daily leg-lifts without fail.

We watch Robin, their now nine-year-old son running across the rocks and marvel that he is alive and well. The bone cancer with which he was born was fatal to all but two babies at that time. Pam reminds me that without discounting the dedicated, long-term caring work of the medical staff at the Sick Children's Hospital in Toronto, she credits Robin's survival to their visit with a spiritual healer. The mother of the only other surviving baby had made the same pilgrimage. I believe that for Pam the spirit is essential to the body's condition and functioning. I am daily aware of and grateful for being alive and having the energy to work and enjoy people. I am sure that both the awareness and the gratitude are part of the reason for my being so.

✖

THE TURN INTO JULY is not only the end of my bonus days; it also warns me that my ninety-second birthday is imminent. I don't dread being a year older, but I do have some reservations about the festivities – mainly the birthday cards that will come and must be acknowledged. Mail up here is no pleasure to me. I can take a phone call in my stride, especially

Woody, Pam, Val, Lynne, and Doris, summer 2002

Doris, Andrew, Larry, and Leslie, 2003 birthday

Andrew, pontificating

if it is either after my working day or before. But mail, coming either by rural delivery or in a batch sent up from Fool's Paradise, must be dealt with, and that often means a whole morning or afternoon away from my easel.

The party – now that is another matter. My dear Leslie and Andrew have called to say they will be driving up from Toronto with dinner and bubbly for four, as Lynne is also coming to stay with me for a couple of days. Both prospects are pure joy. Andrew was my favorite professor at university and is now my addiction. When he and Leslie became partners, she added to the joy.

Lynne Atkinson is now so close and important to me that it is hard to remember when I did not know her. I heard of her first as the new director of Arts Scarborough, who changed the format of the newsletter – for the worse, I believed. (My protests were ignored.) But I soon recognized that if the format was different, so were the spirit and the writing. It was a far better paper than it had ever been. Later that spring of 1988, driving with some artist friends home from a funeral of a Scarborough artist, I aired my need of a dependable cat- and house-sitter while I was away painting in Ireland. Joy McFayden, a mutual friend of ours, suggested Lynne, who was living in Leaside. We met and trusted each other at once.

By the end of that summer she had become part of Fool's Paradise and my life, my family. It was she who raised the funds for Marlene Hilton-Moore's Passage sculpture marking the nature trail near Fool's Paradise. It was Lynne who made sure that after my car accident I had twenty-four-hour-a-day support. She knows my business and continues to monitor

my schedule to protect me from too many demands. Having her come for my birthday was more joy.

Pam and Kit had organized cocktails on the rocks over at the Keyhole and invited the half-dozen or so neighbors who are also friends. This was a lovely relaxed hour, with good nibbles and good talk out in the late afternoon sunshine, with the more intimate dinner at the Knothole to look forward to. Why dread old age when it prompts so many expressions of affection and caring? Old age brings my reward for all the loving I have given in my lifetime, a reward far beyond expectation or deserving.

My birthday passes in a glow of happiness. After Leslie and Andrew leave us, Lynne and I check to see where the cats are and crawl gratefully off to bed.

Even the simple life needs a few simple occasions like this. I enjoy fussing over the dinner table, finding the right wildflowers for a centerpiece and a small bowl to arrange them in, with friends coming to make it a festive meal. My everyday standard of hospitality is to have an open door and open arms, to share whatever I can find in the refrigerator without worrying about it being humdrum. (I once knew a woman who would invite for tea only as many guests as she had matching cups and saucers. Putting things before people seems a poor priority!)

✖

A FEW DAYS LATER, when Joan and David have arrived at the Cubby Hole, Joan joins us for tea and talk. David Smedley is a big friendly guy with a

stubborn streak inherited from his father but usually easy to enjoy a drink and a yarn with. Joan is the daughter of Fred Dashwood, my lawyer in the city. They met at church, when David was fresh out of the navy after the war, and their marriage was a great satisfaction to all. Teatime is better than ever, with Joan to add a new point of view to the discussions.

One of our mutual concerns is the antagonism of the former owners of Jackknife Lodge, once our closest neighbors. We recognize that there are times when anger is justified but agree that whatever the cause it is destructive to the angry person. How to dispel it? We talk about forgiveness and the wonderful release that you feel when you have achieved that. Nursing an injury is a waste of the energy we all need for more important things. I tell her about my toughest experiences with anger and the techniques I discovered to beat it.

I have tried to forget the injustices, as I experienced them, and forgive, with some success. My most difficult time was getting over the church's rejection of the banners I had designed and made – the first of a planned dozen that would transform the chancel of St. Aidan's into the Henry the Eighth chapel at Westminster Abbey. Once the first two were in place I was promised an evaluation. Instead, I came to early Sunday service to find my banners gone, the hanging devices removed from the ceiling, and no explanation offered. I felt that this was a criticism of my professionalism and a breach of faith. The insult was compounded when, at the next vestry meeting, a student at the Ontario College of Art was invited to submit a scheme for redecorating the chancel. It took a lot of prayer and charity for me to stay at St. Aidan's after that, but I was helped by the understanding of my priest friend, Brian Freeland, who

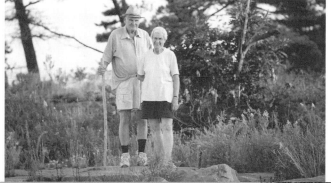

Dave and Joan Smedley

Joan's chair on the point

Doris with Kit, Robin, and Anne, August 2004, on the way to the "Bread & Butter" for fish and chips

promptly got me a commission to create a wall hanging for a chapel in the church home for the aged.

Brian later became director of religious programming for the Canadian Broadcasting Corporation, and he hired me from time to time to create short radio programs, work I loved and did well. We became friends and together subscribed to the National Ballet of Canada's annual Toronto season. We usually preceded the performance with dinner, which kept us up to date on each other's life. Being an artist himself, he could feel for me over the banners.

I can laugh about it now – the best way to forgive and forget – and I tell Joan so. We then discuss the unrelenting resentment against us harbored by the former owners of Jackknife Lodge. They had applied to buy their shore road allowance, thereby cutting off the shoreline from use by others. We supported the appeal of the application by the cottagers on the big island opposite the lodge.

For many years the island people had used a bit of that shore to access the public road: they had rented parking spaces from Jackknife, resulting in income for the lodge and convenience for the islanders. After the council meeting at which the application was granted and the islanders' appeal denied, the Jackknife owners cut off all access to the public road and all parking. The cottagers were forced to leave their cars farther away, which meant a longer boat ride to the island, first over unprotected water, then around our point and into the Keyhole harbor.

Before they sold and moved away I went to see them, reminding them of the many years of friendship and cooperation we had had and to ask them to let bygones be bygones. I was given a bitter, flat refusal that shocked me.

I told Joan about a few other injuries that I have put behind me – the forty-nine paintings that disappeared (were stolen) from the Firestone public collection in Ottawa and have never surfaced; the debasement of my design for the Scarborough flag by using it for a tawdry poster with sentimental renderings of a house and trees. But why waste my precious life spending energy on righteous indignation?

Instead I try to understand the motives that led to the other person's action. It is less apt to be deliberate malice than a failure to share my values, or a failure to consider me or my feelings. Whatever the cause, I have two options: I may try to talk it out to reach mutual understanding, but should I judge that there is little use discussing the matter because there is no common ground, I may choose to forget; every time my thoughts turn in that direction I pull them away to something else. Eventually I can laugh about it. When I say the Lord's Prayer these days, I cannot think of anyone who trespasses against me.

━

MY TALKS WITH JOAN are enriched sometimes by reading excerpts from *Conversations with God* by Neale Donald Walsch, which each of us has read and finds a stimulant to rich discussion. It is a pleasure when a new face turns up around the tea tray and joins in the conversation after the reading, reminding me of my first – and most important – lesson about friendship, which I learned in my teens. A good friendship is open, not exclusive, able to welcome whoever comes, confident that the heart can stretch to fresh love without diminishing the old affection. The very

intensity and openness of the talk this summer impresses me again with the ease with which even strangers can experience love for one another when the deep truths about life are shared.

I have been on a long spiritual journey since the day when I was first taken to Sunday school at St. Aidan's Anglican Church, around age five. It began with a desire to conform to my parents' standards of behavior, in order, I suppose, to live in the glow of their approval. In my teens I was ready to accept confirmation, the Anglican rite by which a young person takes over responsibility for her or his spiritual welfare from godparents and becomes a full member of the Church, admitted to the sacrament of Holy Communion, the Eucharist. I was by this time sincere in my desire to be "good" and took as a given the concept of God that had been taught to me.

Summer camp and the leaders I met there moved me to my first encounter with Jesus the real man. This was so exciting that I knew a missionary zeal to pass on the experience, and the Canadian Girls in Training movement gave me the way to do it. CGIT is an interdenominational program for teenage girls, combining Sunday Bible study with midweek activity based on the doctrine of learning through doing favored by the American educator John Dewey. Becoming a CGIT leader meant studying the Bible and many other sources to deepen my knowledge and understanding, and attending groups led by university professors and other older leaders.

Later, my travels in Israel, some Arab countries, and the Far East made me discontented with the exclusivity of the claims of Christianity. My God was growing – from adherence to one

overarching religion to equal love for all, including those outside organized religion; but I still assumed that He controlled the universe.

Later, the mystery of creation convinced me that God was immanent as well as transcendent – in the rocks, the trees, the animals and me – still creating but not exercising the authority I had once believed in. Then I had to discard the He, because He, She, They, It, Life Force, Energy takes an infinite variety of forms. During all these intellectual shifts I was increasingly experiencing God's presence in my life in a way that made argument irrelevant. You don't need to prove what you know. (Who can prove the power of a great work of art?) You know it because you experience the power.

In every discussion with Pam and Kit and the others, God is here and stays with me, in every aspect of life wherever I am. This colors my days. It makes it possible to "let go and trust," a mantra I often use.

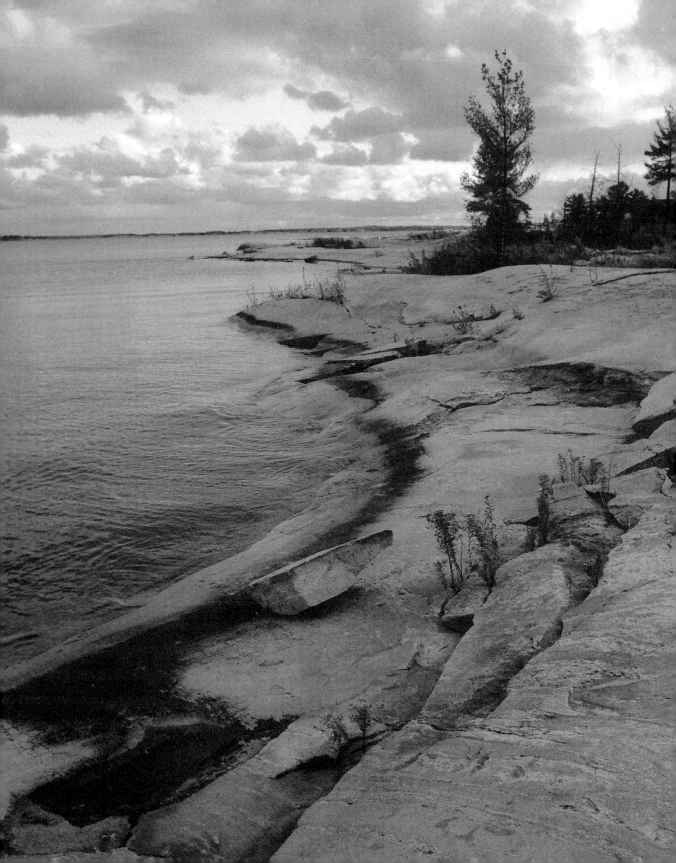

CHAPTER FIVE

IT WAS EASY to let go and trust when I gave my share of the Keyhole properties to my partners. Although I am no longer an owner, we still consider ourselves partners in matters of policy and maintenance. Not long after my birthday we have a business meeting to report on expenses, to estimate the next year's needs, and to work out how much each of us should pay. Since the beginning we have shared a conviction that we are owners of nothing, only stewards. Whoever holds the deed holds the land in trust for the future. It is a satisfaction to me that I have been able to give away both my dear homes to those who will love and care for them.

Ensuring the future of Fool's Paradise is a story in itself. A few years ago a young singer, Lorraine Segato, came to cat- and house-sit for me while I was off on a western painting trip. She had been in poor health and spirits, run down both physically and emotionally. The month at Fool's Paradise proved a time of healing and renewal. Her

gratitude planted a seed that grew into my plan to turn my home into an artists' retreat.

The more I thought about it, the more I liked the idea. It then became a matter of finding the organization best suited to carry out my dreams of creating a place where artists in any discipline could come for focus, healing, and renewal.

A friend recommended a lawyer whose expertise in trusts made him especially appropriate. He and I discussed many options and finally decided to approach Ontario Heritage, as they were accustomed to maintaining buildings and property, not just handling trust funds and giving grants. He and I drafted a proposal and approached Heritage with confidence. They were interested. They came and looked, and liked what they saw. They brought more staff and board members to see the property. My trust-expert lawyer and Ontario Heritage discussed the maintenance of the house and grounds, and agreed that a half-million-dollar endowment would be necessary. I concluded that I could just manage that.

When I proposed that the gift would be immediate with the provision that I could continue to live in my home until my death, I opened up a can of worms. Yes, of course I would pay all the expenses as long as I lived there. Ah, but what if I ended up in a nursing home? What if my final illnesses or incapacity used up all my money and there was nothing left of the endowment? What if I moved away and abandoned the property?

The file grew. Every draft proposal was modified, by their lawyer or mine or me. Weeks grew into months, until finally we all agreed to

accept the compromises and prepare the formal deed of gift. Papers were drawn up (in triplicate, at least – I don't know how many people had to have copies of everything!). One high hurdle passed.

I had had professional assessors inspect the house and grounds; they had prepared an eight-page report that compared Fool's Paradise with every property on Meadowcliffe Drive that had sold in the past ten years. Different assessors evaluated the contents that I planned to give with the house, all those furnishings that I judged to be essential to the character of the place. Yet other assessors put a value on the paintings I was leaving with the house. All these evaluations, for which I paid, were eventually accepted by Ontario Heritage. We had a ceremonial signing of our agreement late in 1998 so that a charitable-gift tax receipt could be issued for that year. The public announcement, with the press invited, and the party of celebration were held in February 1999.

But wait. Ontario Heritage lawyers, digging around in the murky recesses of the registry office, uncovered a joker. Apparently the twelve acres that I had bought back in 1939 had been part of a subdivision that lay east of the Bellamy ravine; because it was inaccessible, cut off by the ravine, it had been sold to me as a block.

Fair enough. The subdivision west of the ravine had a different plan number. But someone, who knows who or why, separated the land registered under the two plans by a one-foot strip. This strip had never been sold or granted, and therefore remained crown land, provincial property. None of this would matter except that the strip lay between me and the road that stops at my gate. I was landlocked, unable legally

to pass over this one-foot strip that I, the conservation authority that stabilized the ravine, and everyone else had crossed happily for more than sixty years. I laughed when I read the lawyer's letter, but lawyers are not paid to be funny. A further delay lasted until, by ingenuity or common sense, the problem was solved and the transfer effected. In spite of the lawyers I am still laughing.

<div align="center">✂</div>

I BELIEVE THAT stewardship has a spiritual dimension that doesn't need religious labels. It is an expression of my belief in the unity of all creation and creation's unity with the Creator. I feel blessed to have friends who can speak this language with me.

There is another friend at Georgian Bay this summer, one with whom I am not able to discuss the spiritual truths that most of us can talk about; however the life of the bay, its birds and animals, our mutual concern for its protection from desecration unites us firmly. Enthusiasm for the same good cause is the basis for many a friendship. We get in a canoe and paddle together down to the beaver meadow, then climb the hill above it to watch the busy creatures drag freshly cut branches to the untidy heap of sticks that is home. Later, we go together to a cottagers' meeting to hear about what parasites are threatening the pine trees this season and what to do about them. She is another one who will write to the township council about the overuse of little Keyhole harbor, which is destroying valuable habitat for much wildlife. I respect her greatly; whatever her theology, she is on the side of the angels.

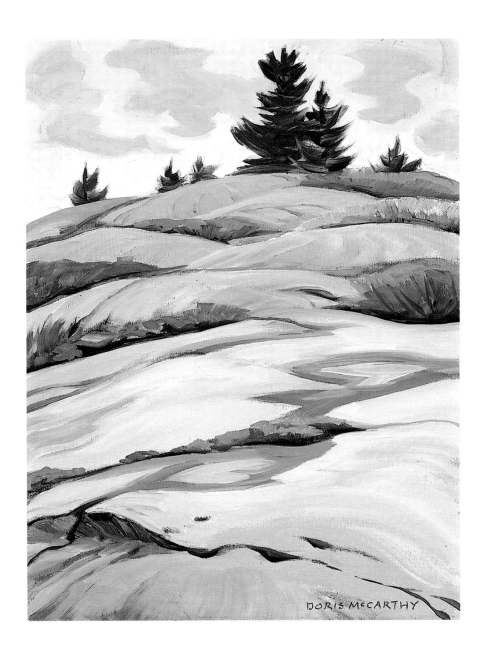

The High Place, completed August 3, 2000
oil on panel, 40.6 x 30.5 cm

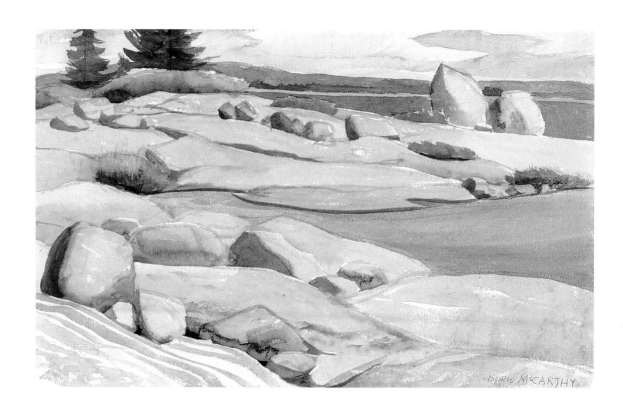

Stone Clutter, completed August 9, 2002
watercolor, 38.1 x 55.9 cm

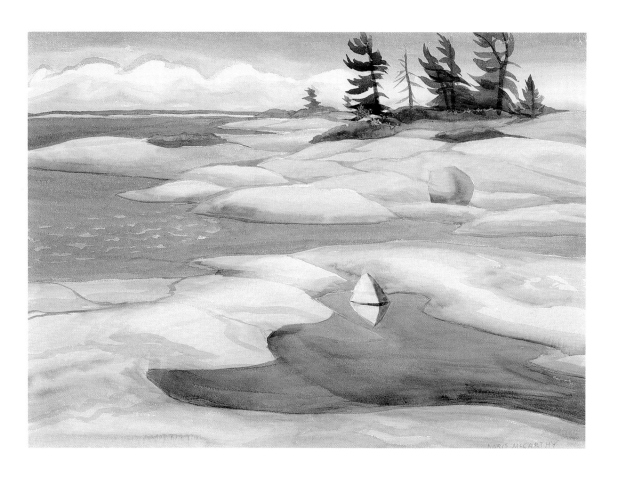

The Little Rock Reflected, completed August 6, 2002
watercolor, 55.9 x 76.2 cm

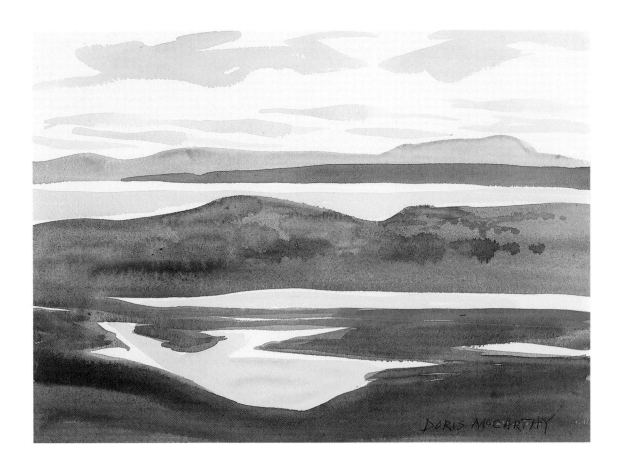

Water Patterns — Below the Park, completed August 17, 2002
watercolor, 22.9 x 30.5 cm

Pam and Kit and I have the same concern for the preservation of the whole of the natural world that the Keyhole partnership has always had. We have less control over what happens beyond our boundaries, but we support and belong to the associations that try to safeguard the environment. There are more of these every day, for which we rejoice and feel that they are doing God's work, loving the Creator through the created.

This month, Barbara, a young artist friend who is also a neighbor in Scarborough, came with her husband. Their camper is parked on the rock up behind Knothole and we are sharing most of our meals. Barbara and I spend our days painting, and David keeps busy doing maintenance jobs that we never seem to run out of – a very practical demonstration of stewardship.

It is a joy to have someone share my art world and to have David caring for the cottage. Although the actual making of a painting is of necessity solitary, and both of us work separately, we meet many of the same problems and share the same hunger for a fellow artist's understanding and encouragement. Getting together afterward to see what each has done is a moment of very special fellowship. Our glass of wine at the end of the day has some of the character of a sacrament, an "outward and visible sign of an inward and spiritual grace," as the prayer book puts it.

—

"Tot time" at Val and Woody's

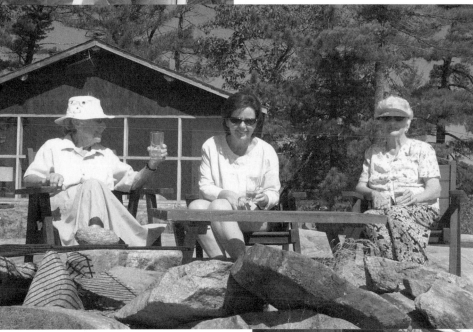

Doris, Lynne, and Rona
Atkinson sharing a beer

Doris and Beth,
bottling rhubarb wine

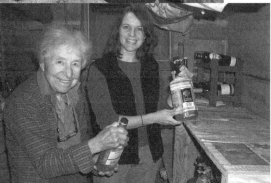

BARBARA AND DAVID are disciplined people, and I learned many years ago never, but *never* to take too much to drink. The lesson came early and with a strong element of comedy. It was on my first painting trip to the Gaspé with two good friends, Ethel Curry and Nory Masters, my colleague in the Central Tech art department. We pitched our tent on the rocky shore beside a clump of spruce, at the foot of a lovely meadow deep in wild irises and daisies. We were able to rent an old empty house a quarter of a mile up the road to use as our kitchen and studio.

One afternoon, Ethel, reacting to my despair over a bad sketch, poured me a stiff Scotch, which I drank gratefully. I was already feeling its effect on my empty stomach when the fisherman's wife who did our laundry came with a bundle of clean clothes. I found it difficult to say the polite things required. My tongue seemed thick. Did Ethel give me another drink? All I can clearly remember is lying on the kitchen floor laughing uproariously – "Hoo-hoo-hoo." I couldn't stop. Nory and Ethel, both thoroughly alarmed, couldn't stop me. "Hoo-hoo-hoo." Together they dragged and carried me to the car, where I lay on the floor, still hoo-hoo-ing.

Nory had never driven my car before and had to follow my directions. "Put the key in and step on the clutch, hoo-hoo-hoo." "Turn on the lights, hoo-hoo." And so on. Somehow she navigated the road and down through the field to the tent, and she and Ethel put me to bed. End of story – and of my overindulgence.

Moderate drinking is an expression of my respect for my body, and of course moderation applies to food as well. Vanity was the root of my habit of eating temperately, to get rid of excess weight, but it is a habit

I recommend. I see fat people in restaurants ordering French fries and cheesecake and wish they knew the pleasure of a body that looks and feels fit. Barbara and David are beautiful people, examples of the rewards of good eating habits.

<p style="text-align:center">⬛</p>

By the end of July I have painted all the canvases I brought with me. Hanging large canvases, three feet by four, to dry is a challenge. The ceiling of the studio slopes from front to back; in order to have canvases hang level I have made hooks of two different lengths from coat hangers. I keep these from year to year, but I must make sure that the screw eyes on each side of the canvas backs are the same distance from the top. (The smaller canvases hang from a different part of the studio ceiling using a different system.)

Usually I wait till Pam or Kit can help – these days the big canvases are too heavy for me to handle above my head. But now they are all in place, and chapter one of my precious summer is over. Cleaning up my oil palette and storing the paints is a bittersweet job and has taken me all morning. But it is done, and I begin to relish setting up for working in watercolor.

CHAPTER SIX

I WORK ON canvases standing so I can easily move back and forth to see if those last few strokes were right. (For a longer evaluation I usually sink gratefully into a chair.) But for watercolor I want to stay close to my easel. I am working in a smaller size and can see what I have done just by leaning back. I work beside a long, low table on my right, with my palette, water pots, and paints within reach. I use a smaller light easel to support the watercolor paper. (Sometimes I use an upturned chair as an easel.) I lay the paper and drawing board flat on the workbench and fasten them both with masking tape. (Since becoming commercially successful I have treated myself to the heavier paper that stays flat without wetting.) One of my favorite sounds of the summer is the rasp of a length of tape coming off the roll. It tells me that the joy of creation is coming.

I start each painting as I did the oils, by propping up a group of on-the-spot sketches to decide which subject to start on. I used to work

out my composition in pencil, but recently I have been brushing in my tentative plan in thin yellow ocher. It seems to encourage a spontaneity and freedom that I value.

＊

AUGUST BRINGS BETH McCarthy and other visitors for a few days at a time; each becomes a comfortable part of any sociability afoot. Beth, my grandniece, has become much more to me as the years pass. She is a beautiful, warm, loving young woman. As a little girl she would visit me at the bay. I thank that child for her expression "hind wash" to describe the clothes on the line at the back of the cabin, and for the question "How can you swim without screaming?"

I found Beth as a young adult increasingly important to me. Her intelligence, high standards, and dependability led me to name her my executor, and I am confident that she will carry out all details of my will and make the many bequests I would have made and approved of. It is a measure of the seriousness with which she approaches this responsibility that with Kirstin, her younger sister, she has made an exhaustive inventory of my possessions and asked my preference as to their disposal. Moreover, she is a good companion, fun to be with, ready to do anything to help, including making each year's batch of rhubarb wine.

Some evenings after my painting day, Beth and I are joined by one or more neighbors on our walks, in our games – Scrabble, or bridge when there are four of us – or for quiet talk around the outdoor fireplace,

watching the night fall and the stars come out as the flames die. Whenever I make a fire, indoors or out, I recite the "Sacrament of Fire" that I learned at camp many years ago:

> Kneel always when you light a fire.
> Kneel reverently, and thankful be
> For God's unfailing charity.
> And on the ascending flame upbear
> The incense of your thankfulness
> For this sweet grace of warmth and light.
> And let it be
> A sacrament for your delight.

—

AUGUST. Summer is half over. In August one very welcome visitor is Marjorie's daughter and my namesake, Margaret Doris. Mar (for short) lives with her family in Ottawa but is lent to me for a few days at a time. It is special to me to be with someone who knew Marjorie and can share with me the memories, the stories, the sayings, and even add to them family lore that is new to me. We recall with enthusiasm the great gathering for the celebration marking the twentieth anniversary of the creation of the memorial banners.

Marjorie and her husband, Roy, had been active members of Metropolitan United Church in Toronto. The Credo group, which she had led, had worked with me to create a memorial to her. It took the

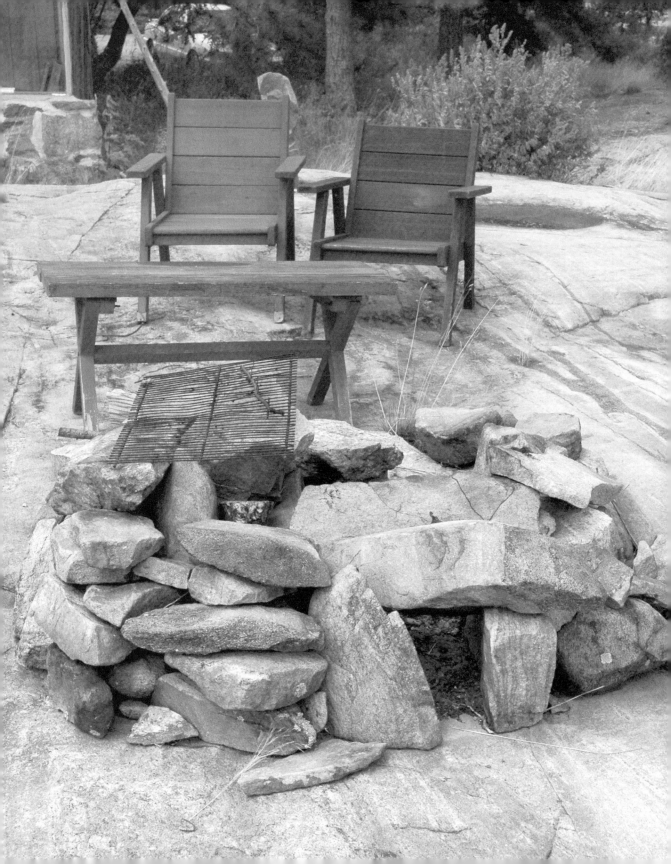

form of two colorful banners framing the chancel arch. More than twenty years after her death, I received a telephone call from someone at the church: the Credo committee wanted to recognize the twentieth anniversary of the banners with a special celebration.

We searched our memory and the church files to find the names of the men, women, and children who had designed and made the panels that make up the banners so that we could tell them of the plan. Many were still alive, and even those at a distance responded enthusiastically and were eager to be part of the celebration. When the day came, a crowd of Marjorie's family and friends swelled the regular congregation. The church was full.

Margaret Norquay first came to the Metropolitan the Sunday after Marjorie's death. She knew nothing of what had happened, but as soon as she entered the church she sensed a community suffering from unmistakable shock and loss. She soon learned the reason for it, and when the memorial plans were forming, she volunteered to become one of the banner makers. Twenty years later, it was she who took on major responsibility for organizing the anniversary service and she who said the opening call to worship.

The service reminded me of the many times Marjorie and I had worked together to design a form of worship for an occasion at a summer camp for a citywide youth conference. Marjorie would have loved this one – the poetic structure of the service, the glorious music, Roy's strong voice reading the Old Testament lesson, the thoughtful sermon by Dr. Clifford Elliott, who had been the Met minister in her day. An especially poignant touch was his reading of Marjorie's meditation

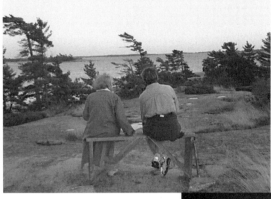

Mar and Doris, playing evening Scrabble

Mar and Doris enjoying the view from Flo's flop

The poem "The Great Lover," by Rupert Brooke, is a favorite poem of Doris' for morning or evening reading

And after, ere the night is . . .
Do hares come out about the corn?

Oh, is the water sweet and cool,
Gentle and brown, above the pool?
And laughs the immortal river still
Under the mill, under the mill?
Say, is there Beauty yet to find?
And Certainty? and Quiet kind?
Deep meadows yet, for to forget
The lies, and truths, and pain? . . . oh! yet
Stands the Church clock at ten to three?
And is there honey still for tea?

Rupert Brooke

THE GREAT LOVER

I HAVE been so great a lover: filled my days
So proudly with the splendour of Love's praise,
The pain, the calm, and the astonishment,
Desire illimitable, and still content,
And all dear names men use, to cheat despair,
For the perplexed and viewless streams that bear
Our hearts at random down the dark of life.
Now, ere the unthinking silence on that strife
Steals down, I would cheat drowsy Death so far,
My night shall be remembered for a star
That outshone all the suns of all men's days.
Shall I not crown them with immortal praise

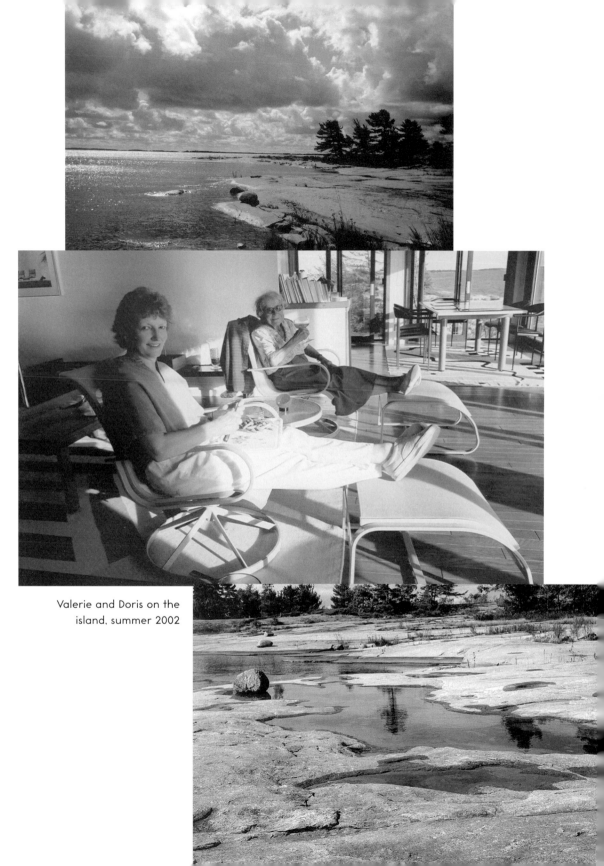

Valerie and Doris on the
island, summer 2002

on death, written not long before she died. I felt her everywhere in that service; in every word said or sung we were together.

Nor was it over at the last amen. Her spirit filled the reception afterward and gave a special flavor to the sandwiches and sweets. Nobody wanted the party to end – people stayed, talking, moving from group to group, sharing memories and euphoria. Death does not end a friendship. Mar and I are proof of that.

<center>✹</center>

THIS IS A GREAT SUMMER. Woody and Valerie Fisher are up on my favorite island, not just for weekends but for the next ten days. They come over in the speedy little launch and pick me up at the dock at the neighboring lodge to whisk me back to a whole different experience of rock and water and twisted trees that cry out to be painted.

Woody and Valerie are the owners of the beautiful island that dominates my view. He is Dr. Murray Fisher, a man with a rather wicked sense of humor – his launch is called *Oceit*, and his business is The Upper Canada Lower Bowel Clinic. We have become great friends through the years, and watch eagerly for the lights or flags that tell us the other is in residence. Valerie is the woman he should have married originally, but they rediscovered each other after the failure of his first marriage and the death of her husband. Their happiness together is palpable and contagious.

Along with Woody's generous drinks and hors d'oeuvres, I feast on the views. I don't leave the Knothole very often, but when I do I am

always struck by the infinite variety of beauty offered by the familiar elements – water, rock, and trees. Their interest is inexhaustible.

―

IN EARLY AUGUST I have produced enough paintings based on the Costa Rica trip. I am no longer inspired by it. I take a deep, satisfied breath and decide to spend the all-too-short remaining weeks in my own special world – out on the point, beside the bay, up on the hill called Ben Hole, and over past the Keyhole.

Working on the spot gives me a whole new opportunity and challenge. Do I take chair, easel, and side table? Do I make do with a cushion, a light carton to lean my board against, and use the rock as a table? Can I carry all the bits and pieces – brushes, paints, water pots – in a tote bag or small backpack? Should I first scout out the land and decide where to settle before I load myself up? Kit offers to be my carrier, but I can manage and I really don't want anyone around while I am looking for my inspiration. It's a very private matter.

Once on location, with my gear arranged around me, I know a short moment of bliss. The possibilities are endless, and I assume I'll be completely successful at this work. You might imagine that after seventy years' experience of painting I would have learned there is never any assurance of success; but not yet, not this time.

Watercolor is completely different from oils. It is quicker to apply and covers a larger area with less fuss. I use flat brushes that make a broad stroke or, turned, give me a line. Each artist I know works

Doris painting, summer 2002

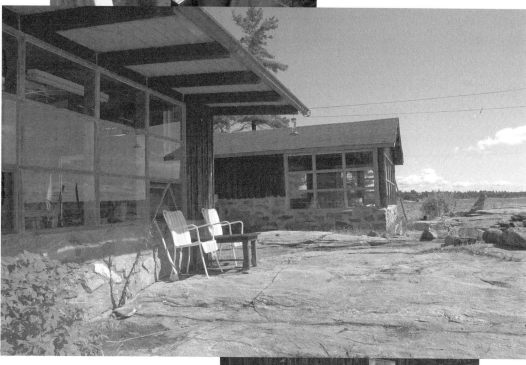

The studio and Knothole

Doris and Mar setting up
the summer's paintings
for photographing

differently. Many paint "wet on wet" – the paper anywhere from running with water to merely damp – with strong color that spreads softly without hard edges. Some use "dry brush," each stroke separate and individually visible. I work on dry paper but with the brush so loaded with color that a wash will flow down the paper if I want it to. My difficulty is to anticipate how that rich color will dry, as it will lighten dramatically. I want to get the full depth of tone in one wash, but I too often find that it is not dark enough when dry. I try to achieve strong lights by leaving areas of the paper bare, relying on the color around it to give contrast that will make the white whiter.

While I have been working, the sun has shifted, and the shadows are both shorter and in a slightly different direction. Every variation of light can lure you away from your original idea. I must decide where to hold the sun so the painting is consistent throughout, with all the shadows thrown in the same direction. I cannot just copy what I see and hope for unity.

Gray weather has much to recommend it. The quality I try for then is very different, without the brilliance of contrast but with a greater subtlety of tone. I love the quiet serenity or mood that an overcast day makes possible.

—

DURING THESE PAST FEW weeks the sun rises later each day, moving from the northeast to east, where I see it above the far shore instead of through trees. The bay is warmer, and the small birch is beginning to turn yellow, a sign of too little rain. I carry an occasional pail of water

to it, probably in vain. The long grasses are like the lass with the flaxen hair, and the goldenrod is flamboyant.

One day Lynne Wynick and David Tuck, my dealers and my friends, come with their two children and a generous basket of food on their annual visit. (Their own cottage is not too many miles away.)

David and Lynne graduated from the Ontario College of Art together and, with a few others, opened a small gallery on Jarvis Street in Toronto. When rising rents pushed them out of that location they moved the gallery, then called the Aggregation Gallery, to cheaper premises, on Front Street, and later to Spadina Avenue, renaming it the Wynick/Tuck Gallery.

I am glad to see them, to catch up on our summers – and then comes the moment I have been waiting for, although not without some anxiety.

We go out to the studio and David lowers the canvases, now dry, and stacks them one in front of the other, ready to put each up on the easel for a good look, both critical and appreciative. I hold my breath. I want to be the kind of person who can learn at any age. I want to be flexible, and I am quite ready to listen to any constructive criticism or reservation offered by them. I look carefully, hoping to see the work with David or Lynne's eye and consider the validity of their points. In the end, I must agree if I am to change a painting, but I have great respect for their opinions and detachment, and I value greatly their candor and tact. We stack the canvases again, and I spread out the watercolors for the same careful appraisal.

I know that it takes time to gain the detachment to judge my own painting dispassionately. I am too emotionally involved with recent work to

be completely unbiased. This makes Lynne and David's approval even more important. They are enthusiastic about what I have done this summer and assure me that it will make a strong show. What more could I ask?

Once again we become sociable, sharing tea while the kids have one last swim, and with regrets on both sides, I see them off to their own cottage farther north.

CHAPTER SEVEN

THAT VISIT is a milestone in the summer, making me realize that there are far too few days left. One of the chores – and it is a chore – is to make a slide record of each work. I have already created an index card for each painting, noting the date of completion and title, size, and medium, but before my records are complete each card must have the right image taped to the back. It is a big job. I used to photograph my canvases in the afternoon sun on the outside west wall of the studio, but the trees have grown so well that there are too many shadows dancing about now. For the past two years I have used the east wall, in shade, with adequate results.

On cataloging day – one without too much wind – Pam asks to help. Two persons cooperating make a huge difference. Three is even better, and Sarah, Pam's lovely daughter, joins us. Pam hangs each canvas on the screws placed the right distance apart. The edge of the stretcher rests on them and they are level. I focus, wait for any passing fly or blowing leaf to go away, and snap a picture, twice. (I want an extra slide of each work for

my files.) Sarah carries the canvas into the studio as Pam sets up the next. I can stay with the camera. No time is wasted – it has never been so easy.

I photograph the watercolors against a big paperboard that I have painted black and to which I have nailed a black wooden ledge. The paper sits on that ledge, held in place by a couple of loops of masking tape on the back.

The toughest job of the summer is done. Hurrah!

Alas, it also means I have more or less finished painting. I will spend the few remaining days cutting down the shrub that has been growing up around the maple; pruning back the juniper bushes that threaten to take over here and there; carrying away the recycling box to the dump; and making inventories, one of what I am going to leave at the cottage and another of my paints so I know what to re-order. I really love any tidying job; all the details of packing and storing are a pleasure to me, although I deplore the reason for them.

Teatimes are more precious than ever, and I am invited out for one or two valedictory meals. That means a reorganization of the kitchen move-out. I have planned the food so carefully that I shall now have more to take back to the city. That will make my return easier – I won't have to shop for a couple of days. And the bottles of wine I take to the dinners reduce the bulk and weight of the cartons of leftovers.

I make lists and cross off the jobs as they are accomplished. What would my life be like without lists? I can hardly imagine, and I certainly don't intend to try to find out. Lists let my mind stay free to enjoy what I do instead of worrying about forgetting something.

All but the last-minute jobs are done. Rick is due tomorrow. Things

Doris signing the lower right-hand corner of a completed painting, August 2004

Early morning fire, August 2004

Photographing work, summer 2002

to do tomorrow are listed so I can stop thinking about them. I am free to have my last luxurious dinner alone and then walk the boundaries and say goodbye to every dear landmark. When I get back I take in the flag and the wind chimes that have hung on the clothesline all summer. And after one more game of Scrabble I go to bed, but I'm too keyed up to sleep immediately.

On those rare nights at the cottage when sleep just doesn't come I play a game that is almost better than sleep. I lie quietly with my eyes closed and remember with gratitude the dear people, many now long since dead, who have given me such a rich and happy life. High school teachers, CGIT leaders, inspiring artists from my art college days, painting companions, neighbors, family. I say thank-you to each of them, hoping that the love I feel can reach them wherever they are. Long before I have exhausted the list I am asleep.

As always, tomorrow comes – and so does Rick. I have managed to get Worcester into his crate and Tigger and Gwen locked in the studio so they can't disappear. (Of all the closing-up jobs this gives me the most anxiety.) The food has been sorted into appropriate cartons and labeled. The boxes of painting gear are packed in the car, as are my clothes.

Rick is able to get into his car all the leftovers, the canvases, and Worcester, in the big cat crate. We lock and fasten the cottage windows. (Later, Pam and Kit will carry in the outside furniture and canoes and batten everything down for the winter.) Last of all, we bring Tigger and Gwen from the studio into my car.

✖

WE HAVE A DATE halfway to Toronto, at Hillsdale, for a comfort stop and a bite of lunch with my dear Marlene Hilton-Moore. She has set the table in the big farm kitchen – we let the cats loose in her enclosed porch – and we settle ourselves to hearty homemade soup. I am to take home with me the model of the big sculpture Passage, which I lived with all last spring and reluctantly gave back to her for the summer. (She lends it to me when she doesn't need it for professional purposes.) When we have stowed it carefully, reassembled the cats, and given Marlene a last hug, Rick and I are once more on the road to what I must now call home.

Packed with me, although invisible, are the resolutions I have made – to govern my life differently, sternly refusing to let every day, every week, become so crowded with engagements that I forget to take time to be aware, to relish the details and keep them under control, and to thank God not only daily but every hour for His/Her/Their wonderful gifts of life, of work, of love, of joy.

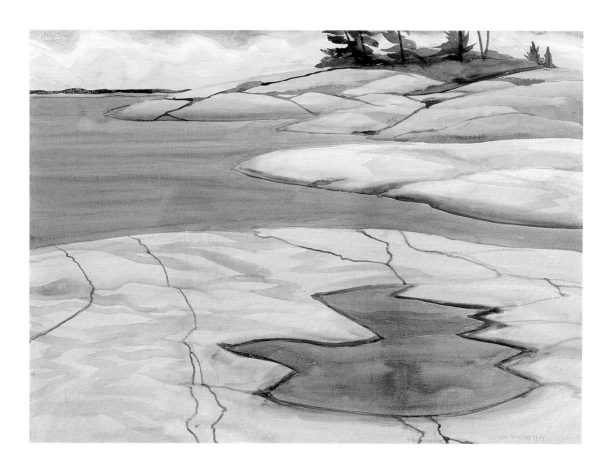

From Beth's Spot, completed August 7, 2002
watercolor, 55.9 x 76.2 cm

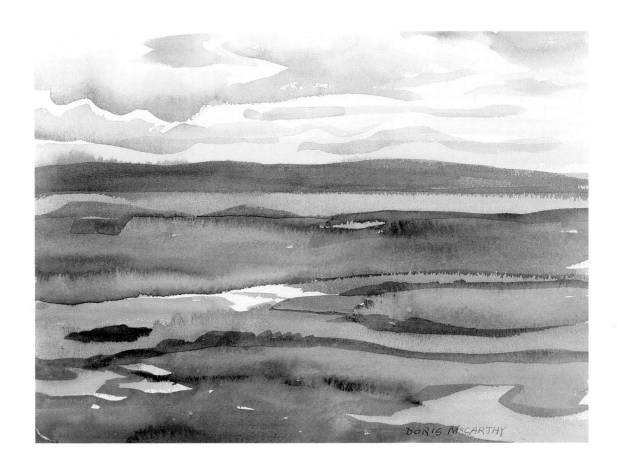

From Sylvia Grinnell Park, completed August 17, 2002
watercolor, 22.9 x 30.5 cm

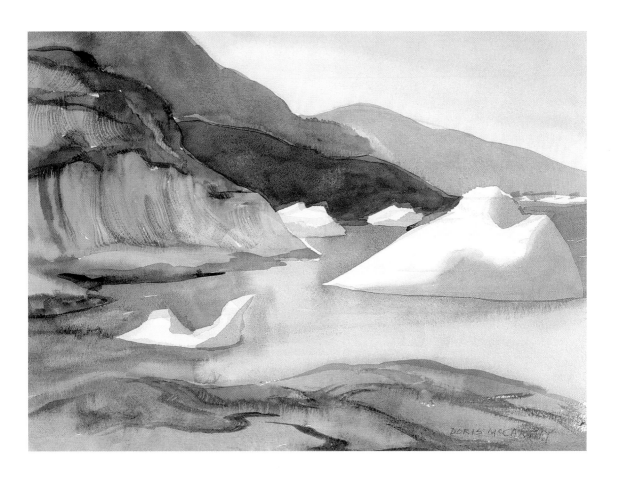

From Grave Sites near Uumannaq, completed August 22, 2002
watercolor, 22.9 x 30.5 cm

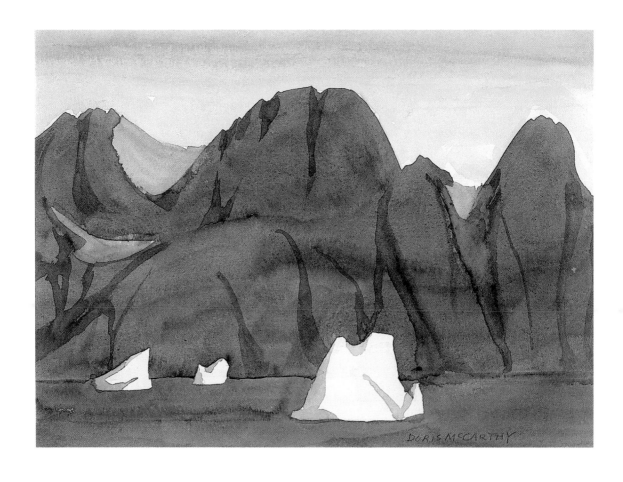

Close to Greenland, completed August 22, 2002
watercolor, 22.9 x 30.5 cm

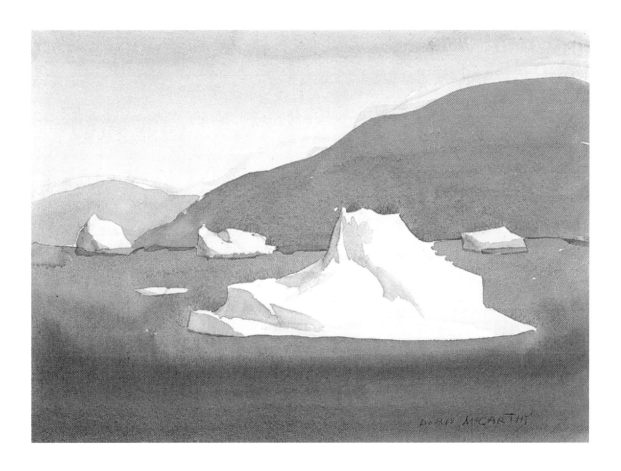

First Impression of Greenland, completed August 22, 2002
watercolor, 22.9 x 30.5 cm

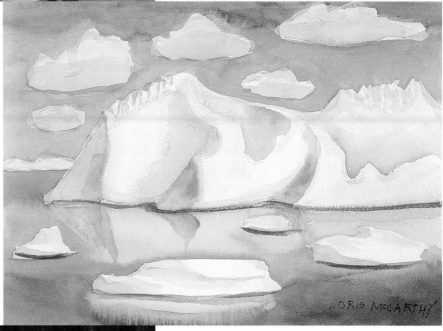

Iceberg off Ilulissat, completed August 23, 2002
watercolor, 22.9 x 30.5 cm

top: the beginnings of The Giant Berg painting

bottom: Doris with the finished painting,
on photography day

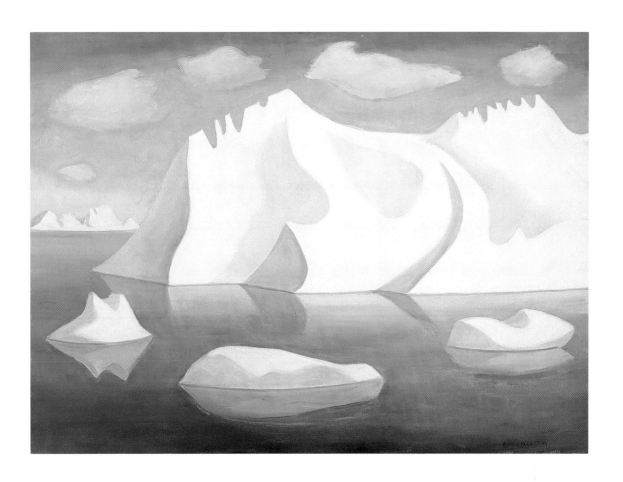

The Giant Berg, completed September 3, 2002
oil on canvas, 91.4 x 121.9 cm

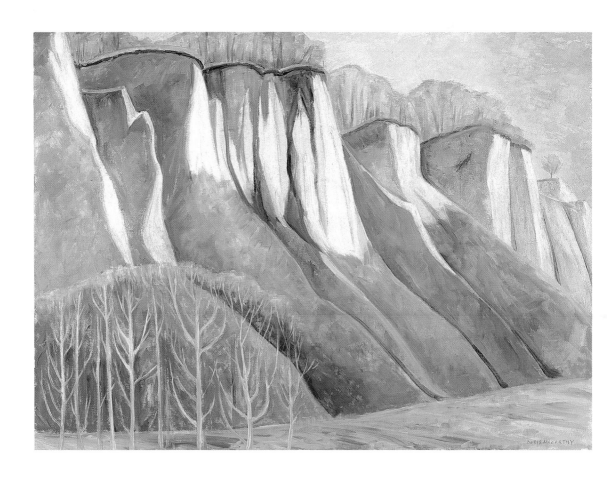

The Eastern Bluffs, completed June 28, 2002
oil on canvas, 91.4 x 121.9 cm

PORTRAIT OF A HAPPY ARTIST

by Sarah Milroy;
reprinted from *The Globe and Mail*,
April 15, 2004

DORIS McCARTHY's idyllic home is perched high atop Scarborough Bluffs, on an expanse of lawn edged by forest and sky. To get to it from central Toronto, you travel eastward along Kingston Road, the main artery that runs through the suburb. This was once the carriage way to the military post at Kingston, but now it is lined with strip malls and fast-food joints and gas stations, a classic example of urban sprawl at its bleakest.

Turning south off Kingston Road toward Lake Ontario, you descend a winding route down through the trees, past quiet homes bathed in mid-morning light, their lawns littered with plastic toys and swing sets, until you reach the end, and a little rustic gate. A small wooden sign, pointed at one end, indicates a left turning in the road, telling you that you have come to the right place: The word "McCarthy" is written in elegant serif script, grey paint on whitewash. The effect is simple, puritan, unassuming but considered, crafted by the careful, steady hand of an artist. Care has been taken over this little sign, and it stands as a signifier for the painter's life and career as a whole.

Doris McCarthy is 93, and as I pull into the driveway, I see her being helped across the lawn – or rather being accompanied across the lawn – by her assistant Linda Mackey and the newspaper photographer who has come to take her picture.

Clad in a woven orange poncho (McCarthy's sartorial tastes were formed in the seventies), a hand-woven grey jacket and skirt, and orthopedic shoes, her silver hair sensibly cropped, she greets me in the main house with an enthusiastic smile, announcing that she doesn't want to go out to lunch (as we had planned) but rather wishes to stay put and have a pizza from the freezer here.

Smiling and congenial, she is at the same time a tad steely in her firmness.

After a moment's deliberation, she settles into an easy chair with a footrest, which I am directed to share with her, dispatching Linda to her defrosting duties. "I tell people what to do all the time," she says, shaking her head at her own bossy ways, but her contrition is unconvincing. Let's put it this way: When she says "sit," I sit.

McCarthy bought this patch of land, she says, back in 1939: 12 acres for $1,250. (She has already bequeathed the house and grounds to the Ontario Heritage Foundation, for use as an artist's retreat after her death, and a chunk of the adjacent land to the local conservation authority.) At first, it was to be a refuge where she could pitch a tent and be close to nature – she was a new painting teacher at Central Technical College at the time, still living at home and just 29 years old – but she soon decided to build a house there and move in permanently.

She named it Fool's Paradise, and she has been very happy there

ever since. In fact, one of the things that strikes you in her presence is that she is a supremely happy person. Happy with her life, a life of (for her) blissful freedom from husbands and children, a life of profound professional gratification (she has numbered Arthur Lismer among her mentors), a life of adventure (from Pangnirtung to Paris), a life of robust friendships and a life of deep spirituality. (She began her devotions leading Christian girl's groups as a teen, serving as a camp counsellor and co-ordinator, and she has continued her daily worship ever since. Her mornings typically begin with Bible reading and prayers in her cluttered little sunroom overlooking the lake.) Spend an hour with her, and it's hard not to feel that she is your new guru.

We are meeting today because tomorrow she plans to be packing and running errands. A three-week painting trip to County Mayo, in Ireland, is in the offing, an excursion with her friend, painter Wendy Wacko. She declares Ireland to be a great place to paint. "Why?" I ask. "Variety of appearance," she answers directly. "Simplicity of life. Sheep. And nice Irish people."

When she comes back, she will be heading straight up to Georgian Bay, where she will rough it and paint the landscape with friends on the little rocky outcropping she keeps to in the summer, with a painting trip to Pangnirtung scheduled for June. Then, it's back in the fall for the usual round of artist talks and studio visits, before she embarks on a trip to Russia.

It's hard, she says, to find the time to paint in the city, and today is a perfect example: lunch with a journalist; followed by a lecture on her art that she must give at 3 p.m. at the new Doris McCarthy Gallery, which

opened three weeks ago at the University of Toronto's Scarborough campus (the first exhibition is a retrospective show of McCarthy's landscape paintings); then dinner at 6 p.m. here at her house with friends. This fall, she will also be publishing her third book, which is currently still in draft form.

Unlike her two earlier autobiographies (which divide her life into early and late periods), this is to be a book that sums up her observations of the world and her place in it. By the time lunch arrives on a tray (McCain's frozen spinach pizza), she is ready to cut to the chase. "What is it, dear, that you would like to know?"

Our conversation ranges over her life, how she wandered sideways into art school (writing was her first love), accepting a scholarship to the Ontario College of Art because she was still too young to go to university, about her parents (her father used to come down to OCA to eat dinner in residence with her and her artist friends, but her mother never accepted her alliances with people she deemed beneath their kind), about studying under Lismer ("He gave me faith in myself. I was a very good student, though, eager, hard-working. He damned well ought to have admired me!") and about visiting Lismer's friend Lawren Harris in Toronto's Studio Building, where Harris showed them his new paintings of the North, kindling a passion that would later take hold in her own art.

I ask her about the prejudice against women artists in her day, a question that seems to bore her. "I was fortunate in that there was very little sexism in the art department at Central Tech," she insists, adding, "I recognize that in terms of promotion it was a problem, but I just didn't care."

Administration wasn't her thing. Her opportunity to teach at Central Tech arose, she says, when a fellow woman artist decamped for matrimony. "If a woman got married, she was out. That was it." She remembers, too, turning down the opportunity to work at the Grip advertising studio, where several of the Group of Seven artists were employed. "They said they'd take me in and they'd let me work," she recalls, "but they wouldn't pay me."

She is eloquent about her first exhilarating forays painting outdoors in the winter, about studying at the OCA with J. W. Beatty ("no great shakes") and Charlie Goldhamer and Emanuel Hahn, about the scandal of the Group of Seven paintings when they first hit the public stage at the Art Gallery of Toronto, about her first encounter with an iceberg near Pond Inlet in 1972 (she and her Inuit guides made tea from the ice), about her admiration for Emily Carr ("now, she was passionate") and about the one great love of her life, who was the husband of a friend of hers. "We were very discreet then, and I intend to remain so," she says, meeting my eye, when I quiz her on the details and adding that, after his death, she and his widow became closer friends.

"She got much better after he was gone," she adds unrepentantly, munching on her pizza.

One of the fascinating things about a few hours with McCarthy is the chance to witness a woman utterly at ease with who she is, and with the life she has led. As well, one can gaze directly into the pool of ideas that sustained the Group and underpinned Canadian art at a crucial moment in its becoming: their love of their country, their essentially unintellectual relationship to their art, their loyalty to nature and their

relative indifference to the history of art as a source to draw from. Making a painting was something to be worked out between you and the trees and rocks in front of you. The work of other artists had no place in the equation.

McCarthy will also talk with gusto about the way the world has changed, which strikes her as being all to the good. "The biggest thing," she says, "is the change in sexual mores, the openness. I think it is healthy. It's much better than what we had. I don't think that young people are going to the dogs, and this idea of young people being able to go to Rome in the summer to study. I think it's wonderful.

"Also, I like globalization. I love the cosmopolitanism of Toronto."

She takes frequent trips downtown, she says, to see theatre, music, dance and art, although she drew the line recently at the Canadian Opera Company's 4½-hour production of Wagner's *Die Walkure*. Still, the prospect of a 21st-century interpretation intrigued her.

Lunch is over, and a little rest is in order, but I am permitted to visit the room where she takes her afternoon nap, a comfortable sitting room with a fireplace, overlooking the lake. As she settles down on the sofa, she directs me to the curio cabinet near the window.

"That is my trophy cabinet. You may look at it," she commands, closing her eyes. Linda and I take a look, noting the photograph of her receiving her Order of Canada in 1986, her Order of Ontario medallion (awarded in 1992) and an invitation to her 85th birthday party, at which her friends presented her with a hand-bound volume of reminiscences. By the time we straighten up to leave her, she is already asleep, hands folded on her chest, a smile of satisfaction on her face.

DORIS McCARTHY — A SHORT BIOGRAPHY

Doris McCarthy remains one of this century's most influential and celebrated Canadian artists. She first exhibited at the Ontario Society of Artists' (OSA) 1931 Annual Exhibition and since that time has shown her paintings across Canada and throughout the world. McCarthy is a prolific artist, having produced more than 5,000 works. She has witnessed and participated in the most important Canadian art developments of the twentieth century and has dedicated more than 40 years of her life to teaching. Her many achievements include being appointed the first woman president of the OSA in 1964, and receiving the Order of Canada in 1986 and the Order of Ontario in 1992. She was presented with the City of Toronto's William Kilbourn Award in recognition of her lifetime contribution to the arts in 1998, and received five honorary doctorates between 1995 and 2002.

Though impressive in scope, these successes constitute only a part of McCarthy's life's work. Her influence on Canadian culture goes much

deeper: as a landscape painter, she has portrayed every province and territory in Canada; as a sculptor and liturgical artist she created one of this country's most magnificent nativity scenes for the crèche at St. Aidan's Anglican Church, Toronto; as an author she has recorded the history of a young artist growing up in early twentieth-century Toronto; as a practicing artist she has traveled extensively in search of new inspiration and mounts a major exhibition of current works each year; and as a philanthropist she has donated her home to be used as a studio and sanctuary by future generations of Canadian artists.

McCarthy was 15 years old when she began her first art studies at the Ontario College of Art (OCA) in Toronto. Arthur Lismer (1885–1969) was vice-principal of the school. Lismer was a member of a collective of artists known today as the Group of Seven. The Group revolutionized the Canadian art scene because, until the early 1900s, the landscape of Canada had not been successfully painted in its own style, represented as having its own character and spirit, or valued by Canadian artists for its unique beauty. Lismer noticed McCarthy's talent, and at the end of that first year he awarded the young artist a full-time scholarship to the college.

At that time, Doris went on her first significant painting trip. With a few artist friends, she traveled to a remote location on the Grand River in Southwestern Ontario and stayed for a month. Each artist would go outdoors, paint all day, then bring her work back for discussion at night. The pattern established on this trip – painting outdoors and critiquing work amongst friends – has been part of McCarthy's life ever since.

In 1930, McCarthy re-established her professional connection with Lismer, who had become Supervisor of Education at the Art Gallery

of Toronto (now the Art Gallery of Ontario). One of Lismer's primary interests was the artistic education of children. Committed to the idea that every child could be invigorated by art, Lismer worked tirelessly to provide accessible art instruction. He believed that the artistic impulse inherent in all people should be encouraged and allowed to find natural and simple forms of expression. McCarthy embraced Lismer's philosophy, and was asked to join his staff. Saturday morning art classes began in February 1930, and hundreds of children from all of Toronto's different neighborhoods and economic classes appeared at the Art Gallery for instruction. McCarthy taught these morning classes for five years.

In the midst of the Depression, McCarthy joined the staff at Central Technical School in Toronto, where she taught for more than 40 years. Many prominent artists worked under her careful guidance, including Harold Klunder and Joyce Wieland. Central Tech's program was unique at the time because of its mandate, which stipulated that teachers must be practicing artists. As a result, McCarthy traveled the world to photograph and sketch its many wonders, believing that it was important to visit the sites that she lectured about. To stay current for her students, she also explored the major new art movements that emerged during the 1950s and 1960s.

In 1939, Doris bought a scenic property nestled high on the Scarborough Bluffs. Her mother did not approve and thought the purchase extravagant and foolhardy for a young teacher. She told Doris that the site was a "Fool's Paradise" – a name that has stuck to this day. Doris acted as her own contractor and built much of her treasured dwelling with her own hands and those of friends. During World War II, Doris and her friends

took great pride in the enormous "Victory Garden," where they grew vegetables to support the war effort. In 1959, in partnership with artists Virginia Luz, Yvonne Williams, Margaret Cork, and Gwen Oliver, McCarthy purchased property on Georgian Bay, "Keyhole," where she still spends most of her summers painting. In 1998, she announced her plans to donate Fool's Paradise to the Ontario Heritage Foundation along with a $500,000 endowment to be used to maintain the property in perpetuity as a retreat for developing artists, musicians, and writers.

Since her retirement from teaching in 1972, McCarthy has enjoyed the freedom of fewer demands on her time and has traveled extensively, constantly discovering new landscapes to interpret. McCarthy has always possessed an abundance of energy and enthusiasm, and over the years she has traveled to, and painted in, numerous countries, including England, Ireland, Scotland, Holland, Germany, Austria, Italy, France, Greece, Japan, Hong Kong, New Zealand, Singapore, Thailand, Cambodia, India, Afghanistan, Iran, Iraq, Turkey, Greece, Egypt, Israel, Spain, and throughout the Arctic.

Each time she opens a new show, hundreds of admirers come on opening night to pay homage to this extraordinary artist and woman. With a gallery established in her name at the University of Toronto in 2004, Doris McCarthy will continue to be an inspiration for years to come.

DORIS McCARTHY CHRONOLOGY

1910 Born in Calgary, Alberta, on July 7

1913 Family moves to Toronto, Ontario

1918 Meets Marjorie Beer and they become close friends

1921 Enters Malvern Collegiate Institute, Toronto, Ontario

1922 Begins what becomes a life-long commitment to journal writing

1925 Enrolls in a junior course at the Ontario College of Art (OCA),
 taught by Grace Coombs (*Principal: George Reid; Vice-Principal:
 Arthur Lismer*)

1926 Wins full-time OCA day scholarship for the fall

1927 Meets Ethel Curry and they become close friends

1929 Arthur Lismer offers her a Saturday morning teaching job at the
 Toronto Art Gallery (now the Art Gallery of Ontario)

1930 Graduates with honors and special prizes from the OCA
 Begins teaching children's classes at the Art Gallery of Toronto,
 1930–1935

1931 Begins to actively exhibit her work

1932 Begins teaching at Central Technical School, Toronto, 1932–1972

1933 Graduates from the Ontario College for Technical Teachers, Hamilton, Ontario

1935 Begins post-graduate studies in painting at Central School of Arts and Crafts, London, England

Takes life classes at Royal College of Art

1936 Sees her first iceberg while returning from England aboard ship

1937 Makes her first trip to Western Canada in July

1939 Buys property on Lake Ontario – several years later her mother calls it "Fool's Paradise," a name that sticks. In 1998 Doris donates the property and her home to the Ontario Heritage Foundation to be used as an artists' retreat after her death

1945 Elected as a member of the Ontario Society of Artists (OSA)

1946 Winterizes Fool's Paradise and moves in

1950 Begins a one-year sabbatical in June and spends it with fellow teacher and artist, Virginia Luz, in Britain and Europe. Visits England, Ireland, Scotland, Holland, Germany, Austria, Italy, France and Greece

1951 Elected associate of the Royal Canadian Academy of the Arts (RCA)

1952 Elected member of the Canadian Society of Painters in Water Colour (CSPWC)

1954 Receives Ontario Department of Education Specialist Certificate in Art

1956 Elected president of the CSPWC and serves in this role until 1958

1959 Buys two cottages on Georgian Bay, "Keyhole" and "Knothole," in

partnership with other artists – Virginia Luz, Yvonne Williams, Margaret Cork and Gwen Oliver

1960 Adds studio to Fool's Paradise

1961 Begins another sabbatical, this time alone, and ventures to Japan, Hong Kong, New Zealand, Singapore, Thailand, Cambodia, India, Afghanistan, Iran, Iraq, Turkey, Greece, Egypt and Israel (1961) before returning to Rome, Spain, France and England (1962)

1964 Elected president of the OSA, continues in this role until 1967

1966 Founds Patrons of Canadian Art

1968 Honored as Painter of the Year by Canadian Women's Club of London, London, Ontario

Designs official flag for her home city of Scarborough, Ontario

1969 Arthur Lismer dies

1972 Retires from 40 years of teaching at Central Technical School

First of many trips to the Arctic – creates Christmas cards based on iceberg images

1973 Lectures at the Robert McLaughlin Gallery, Oshawa, Ontario

Receives full membership in the RCA

1974 Elected academician of the RCA

Dear friend Marjorie Beer dies

1975 Coordinates the design and fabrication of a memorial banner for Marjorie, to be installed in the Metropolitan United Church, Toronto, Ontario

1977 Begins to paint on larger canvases

1979 Begins to show with Wynick/Tuck Gallery, Toronto (formerly Aggregation Gallery)

1982 Receives Civic Award of Merit from the City of Scarborough, Ontario

1983 Subject of the award-winning documentary film entitled *Doris McCarthy, Heart of a Painter*, produced by Wendy Wacko, W. Wacko Productions Limited, Jasper, Alberta

Receives Tia Maria Award as Canadian Woman Artist of the Year

1986 Appointed Member of the Order of Canada (CM), December 29, Ottawa, Ontario

1989 After 15 years of courses, graduates with an honors degree in literature and a prize for highest standing in the humanities, University of Toronto

1990 Her first memoir, *A Fool in Paradise: An Artist's Early Life*, is published by MacFarlane Walter & Ross, Toronto

Appointed an Honorary Fellow of Ontario College of Art

1991 Major retrospectives of McCarthy's work, *Doris McCarthy: Feast of Incarnation, Paintings 1929–1989*, are mounted. Organized by the Gallery/Stratford, Stratford, Ontario. Exhibited at the Gallery/Stratford – May 28 to September 2; MacLaren Art Centre, Barrie, Ontario – September 6 to October 13

The Good Wine, written by Doris McCarthy, is published by MacFarlane Walter & Ross, Toronto

1992 Appointed to the Order of Ontario, April 28, Toronto, Ontario

Feast of Incarnation, Paintings 1929–1989 exhibited at Chatham Cultural Centre, Chatham, Ontario – February 13 to March 29; Point Claire Cultural Centre, Pointe Claire, Quebec – July 27 to September 13; McMichael Canadian Art Collection, Kleinburg,

Ontario – December 6, 1992 to February 21, 1993

1993 *Feast of Incarnation, Paintings 1929–1989* exhibited at the Art Gallery of Algoma, Sault Ste. Marie, Ontario – April 7 to May 17; Thunder Bay Art Gallery, Thunder Bay, Ontario – June 4 to July 15; Robert McLaughlin Art Gallery, Oshawa, Ontario – August 19 to October 17; Justina M. Barnicke Gallery, Hart House, University of Toronto, Toronto, Ontario – November 18, 1993 to December 16, 1994

1994 Expands the studio at Fool's Paradise by adding a study
Feast of Incarnation, Paintings 1929–1989 exhibited at Carleton University Art Gallery, Ottawa, Ontario – January 2 to February 27; Peterborough Art Gallery, Peterborough, Ontario – March 3 to April 3

1995 Receives Honorary Doctorate of Laws from the University of Calgary

1996 Honored by the City of Scarborough with "Doris McCarthy Day," June 4th

1998 Receives Honorary Doctorate of Letters, Nipissing University, North Bay, Ontario
Receives William Kilbourn Award from the City of Toronto Arts Foundation
Becomes an Honorary Life Member of the Society of Canadian Artists (SCA)
The Centenary site of the Rouge Valley Hospital chooses to honor Doris by naming its new neonatal unit after her
Donates her beloved home, Fool's Paradise, and a $500,000 endowment to Ontario Heritage to be used as an artists' studio/ retreat after her death

1999 *Doris McCarthy: The View From Here* published by The Mississauga Art Gallery

Celebrating Life: The Art of Doris McCarthy published by The McMichael Canadian Art Collection

2000 Becomes the first recipient of the Julius Griffith Award on the occasion of the 75th anniversary of The Canadian Society of Painters in Water Colour

Receives an honorary Senior Signature membership (SFCA Hon) from the Federation of Canadian Artists

2001 Honored by the City of Toronto with the Doris McCarthy Trail – a recreational trail that runs through Bluffer's Park, Scarborough

Receives Honorary Doctorate of Laws from University of Toronto, November 20

2002 Receives Honorary Doctorate of Laws from Trent University, Peterborough, Ontario, May 31

Receives Honorary Doctorate of Laws from the University of Alberta, Edmonton, Alberta, June 10

Receives the Lifetime Achievement Award from the Scarborough Chamber of Commerce

Honored with the installation of *Passage*, a sculpture to mark her relationship to the land, October 31

2004 Honored by the University of Toronto, Scarborough Campus with the opening of the Doris McCarthy Gallery, March 11

Everything Which Is Yes, a retrospective of McCarthy's work, opens at the Doris McCarthy Gallery